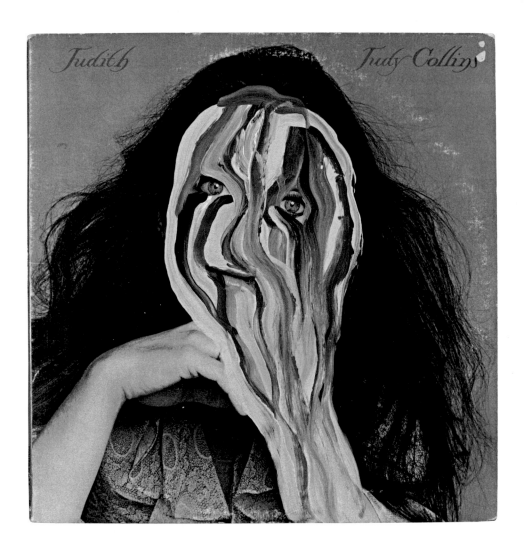

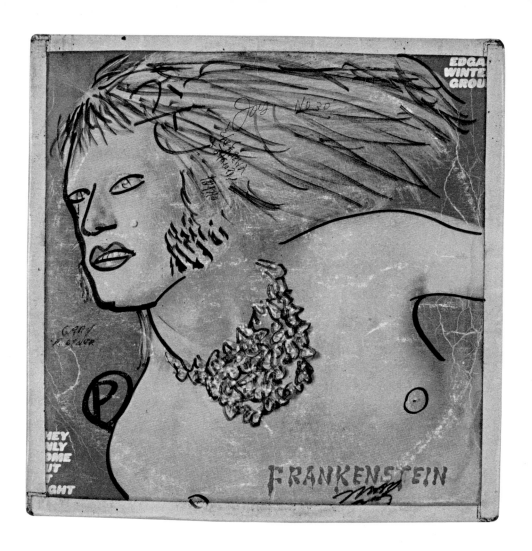

YAWN.

MARRED FOR LIFE!

DEFACED RECORD COVERS
FROM THE COLLECTION OF GREG WOOTEN

⌐L

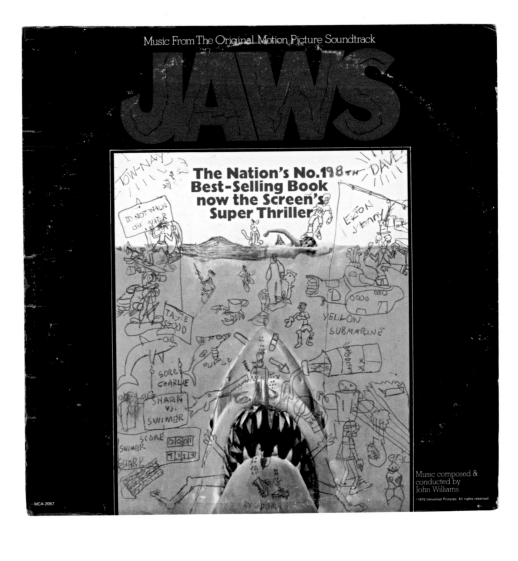

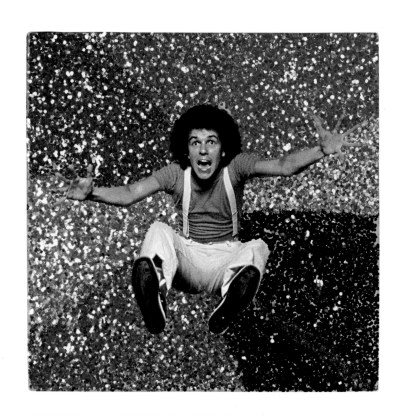

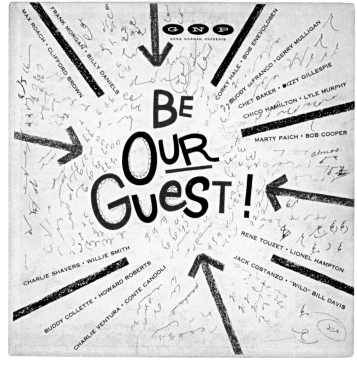

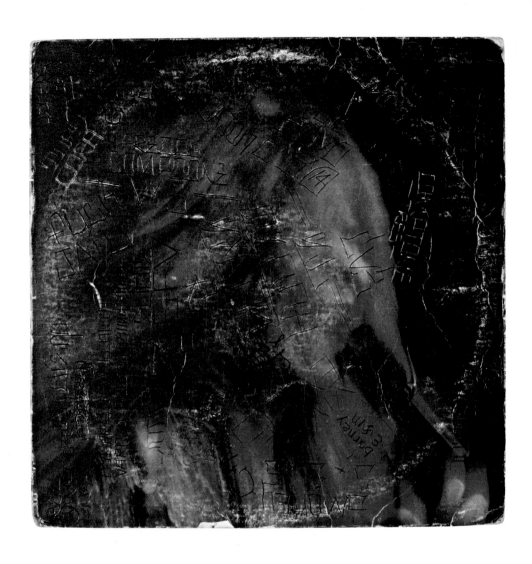

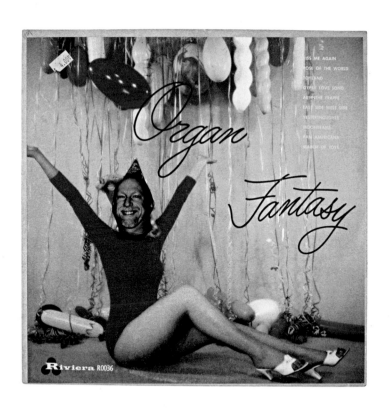

Organ Fantasy

KISS ME AGAIN
ROSE OF THE WORLD
TOYLAND
GYPSY LOVE SONG
ABSINTHE FRAPPE
EAST SIDE WEST SIDE
YESTERTHOUGHTS
MOONBEAMS
PAN AMERICANA
MARCH OF TOYS

Riviera R0036

Debbie Gibson
Out of the Blue

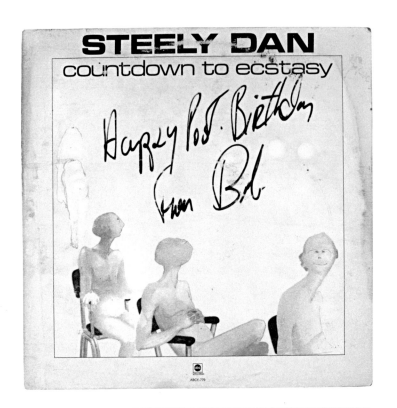

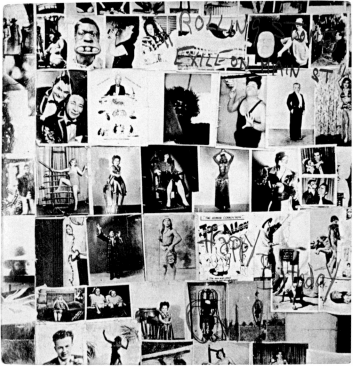

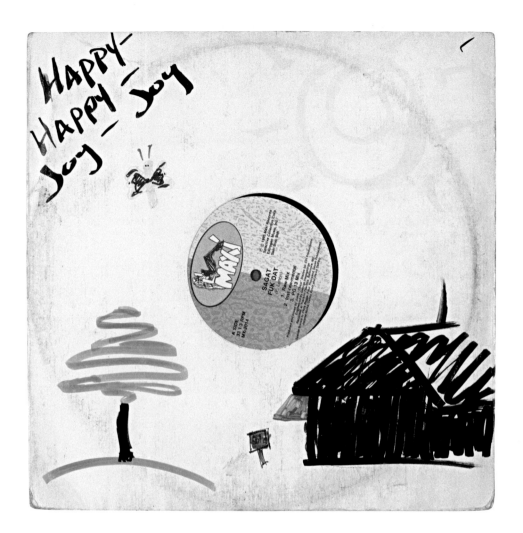

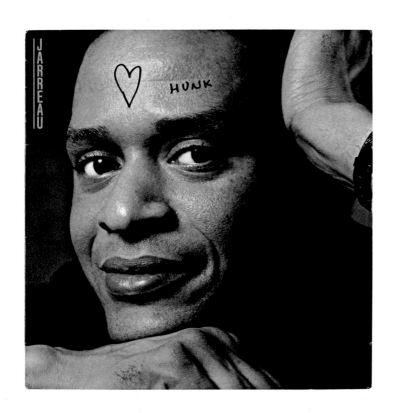

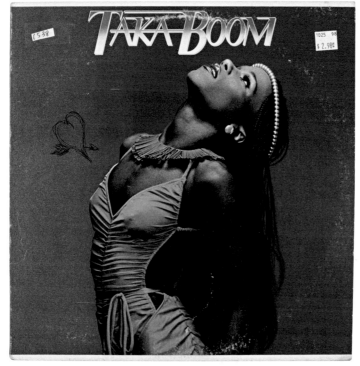

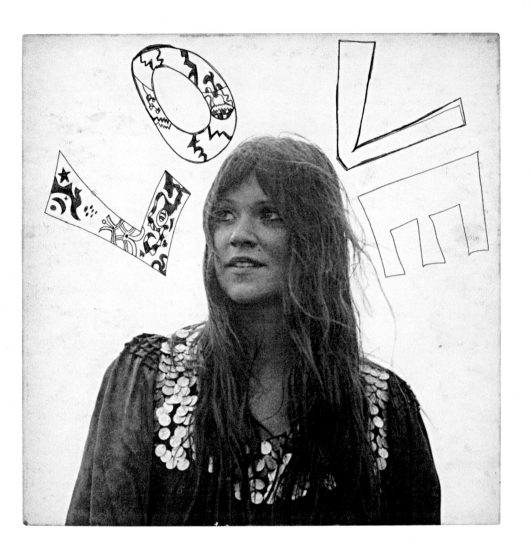

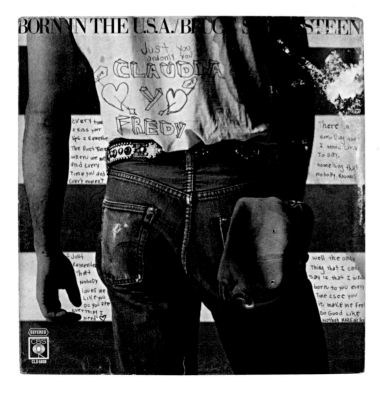

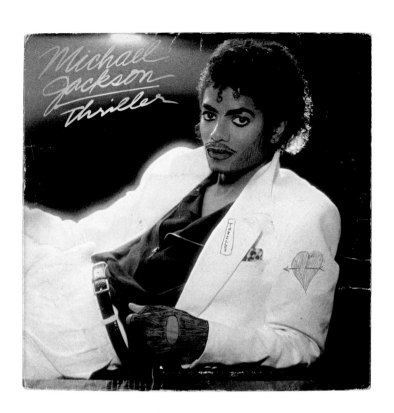

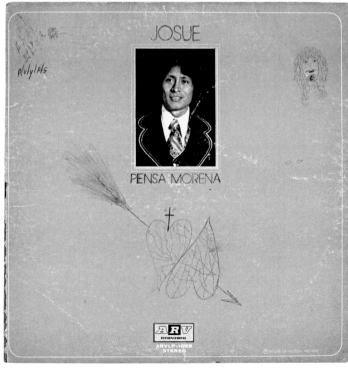

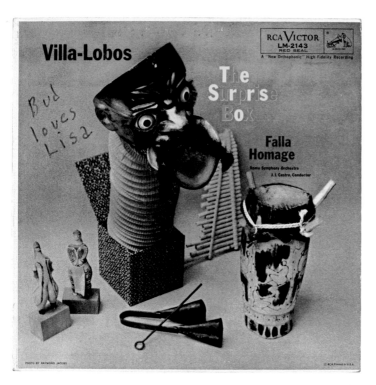

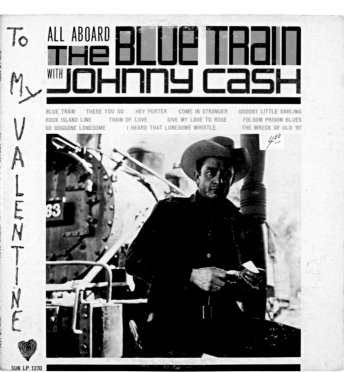

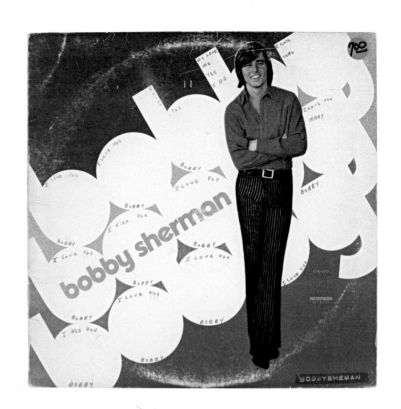

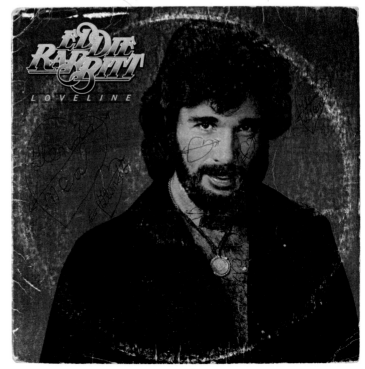

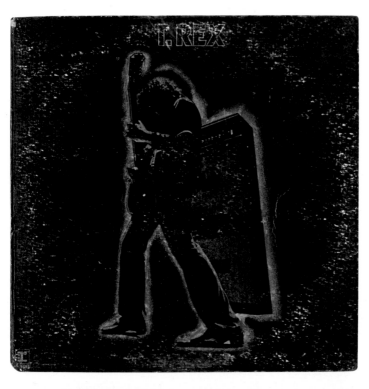

STEREO PAS 71014

AT THE TALK OF THE OWN

AIN'T	GOOD NEWS
HELL	LOVERS
I CAN	STOP LOVING YOU
	NEW PUSSY
NOT RESPONDING	
I	LIE
I DIE	MOM
	AK
HA UCK O SUN	
GREEN, GREEN	ASS OF HOME
IT'S NO	USE
LAND OF	BAND

rot®

A DIVISION

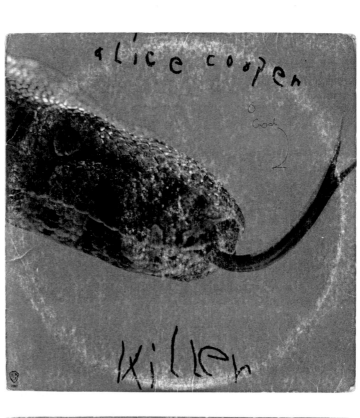

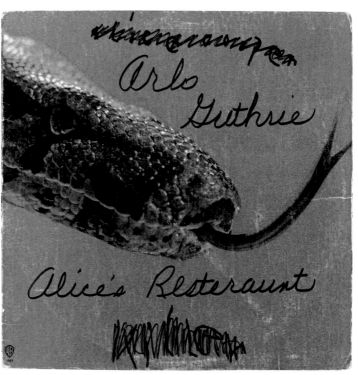

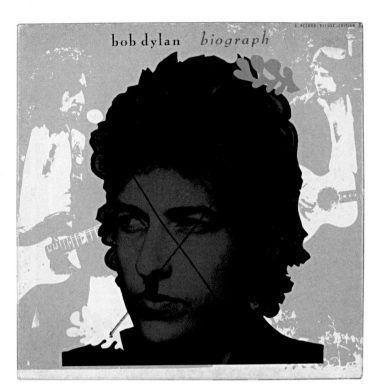

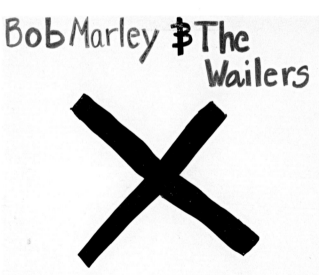

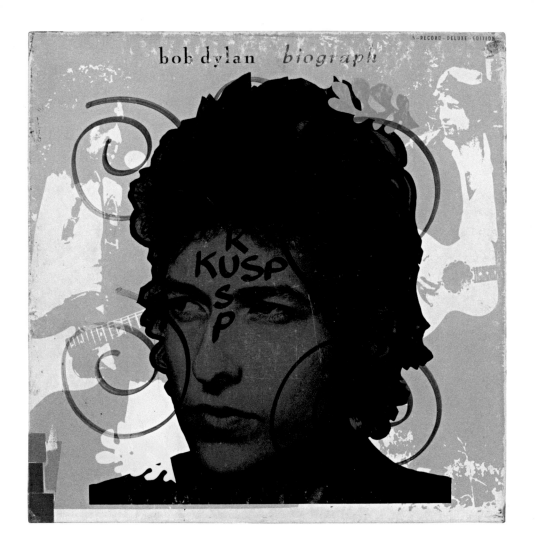

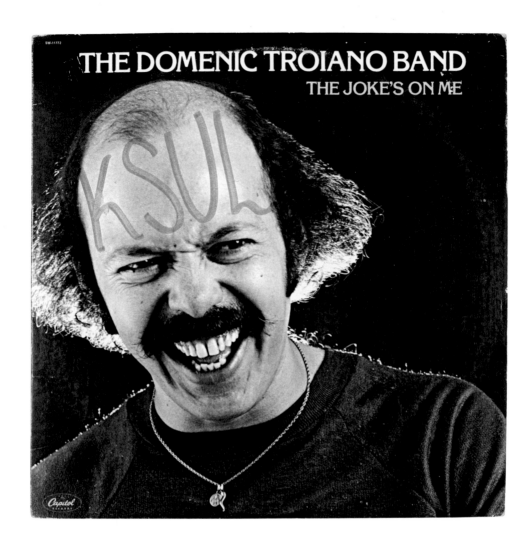

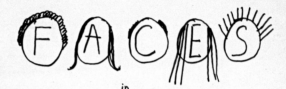

Warner Bros. #
WS-1892

Stereo

FACES

in

LONG PLAYER

STAY WITH ME KIKI DEE

Dee
11-6-78

KCR KCR

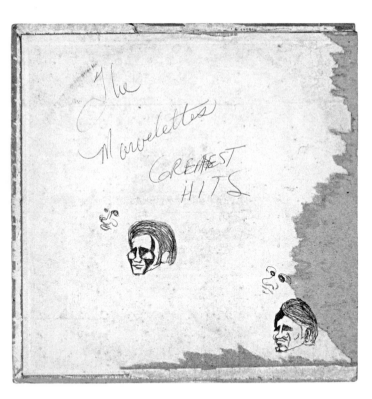

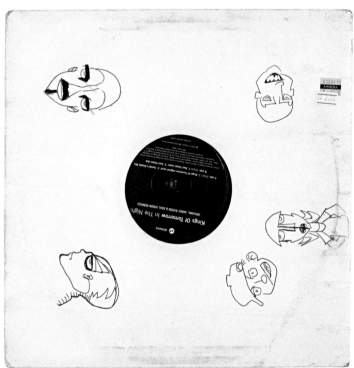

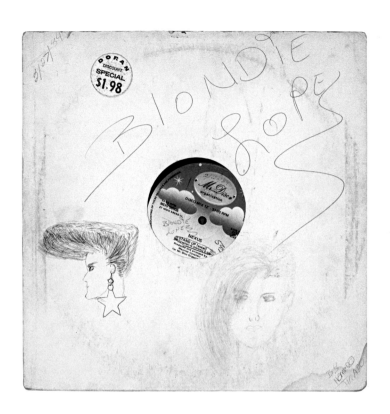

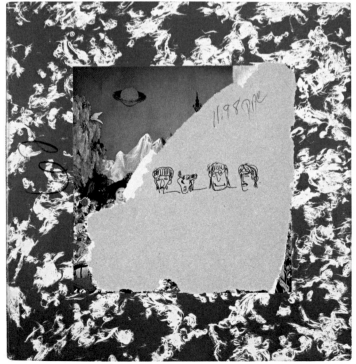

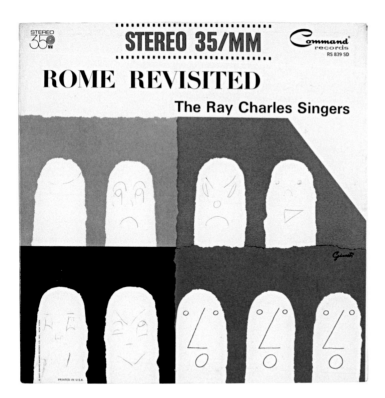

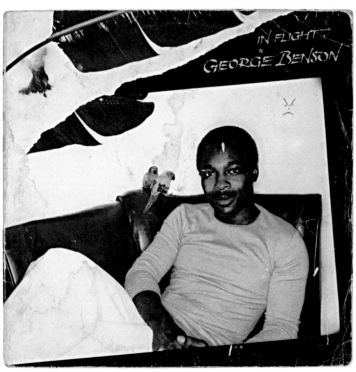

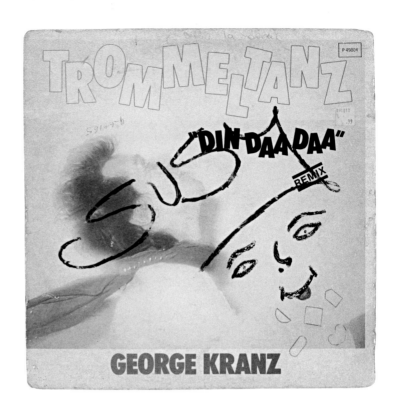

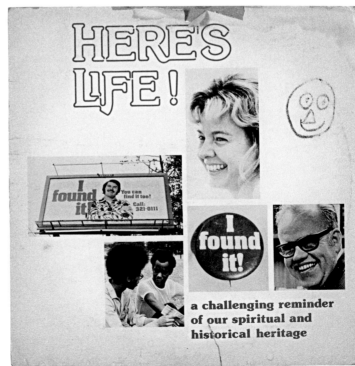

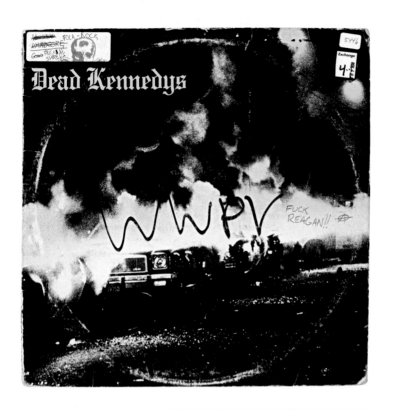

Dead Kennedys

WWPV FUCK REAGAN!!

SEX PISTOLS
BOOT LEG

18

Q: What was Tom Hayes' Puberty Like?

Nonexistent

Answer ————————>
(over)

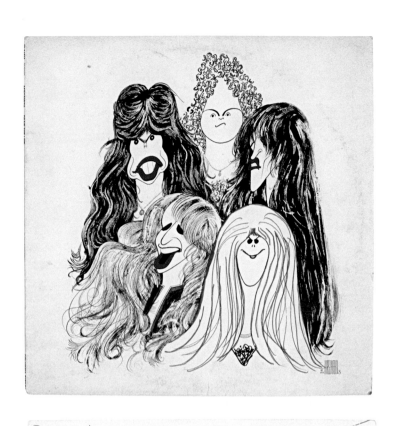

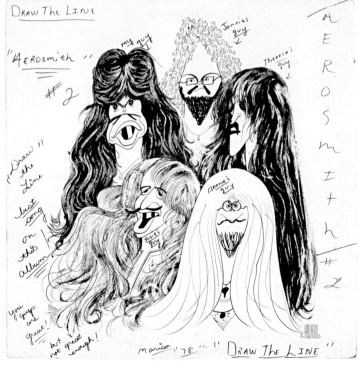

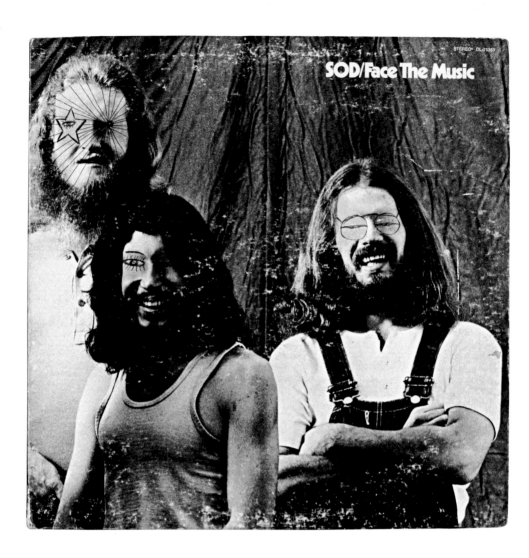

STEREO DL-75353

SOD/Face The Music

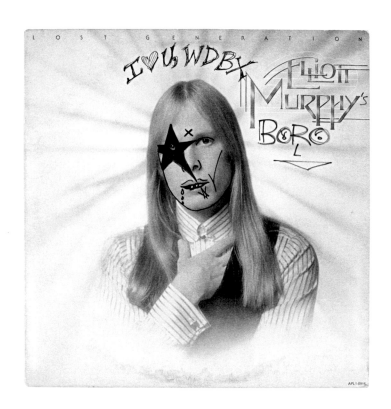

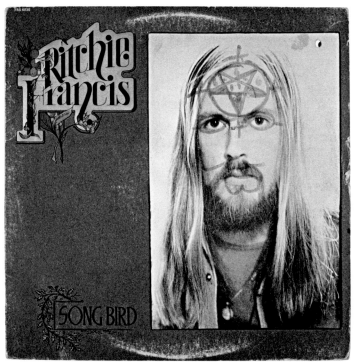

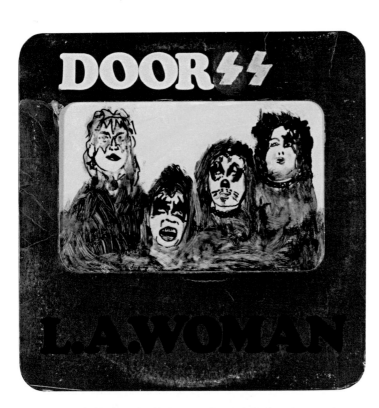

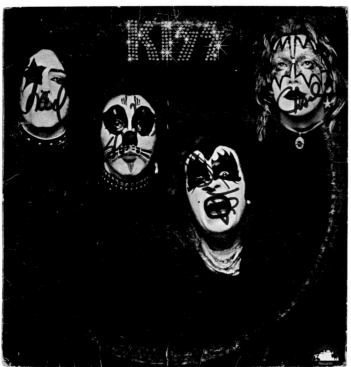

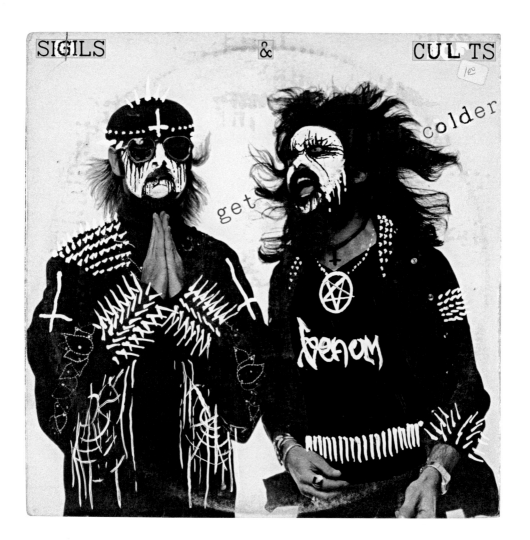

get colder

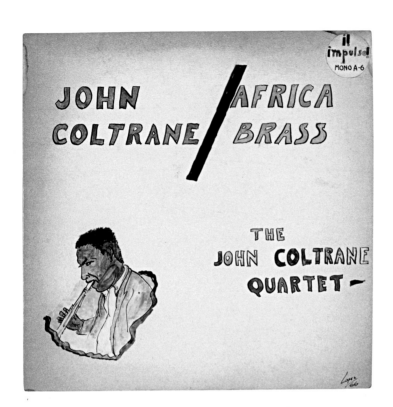

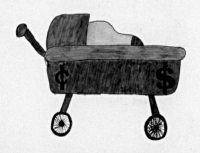

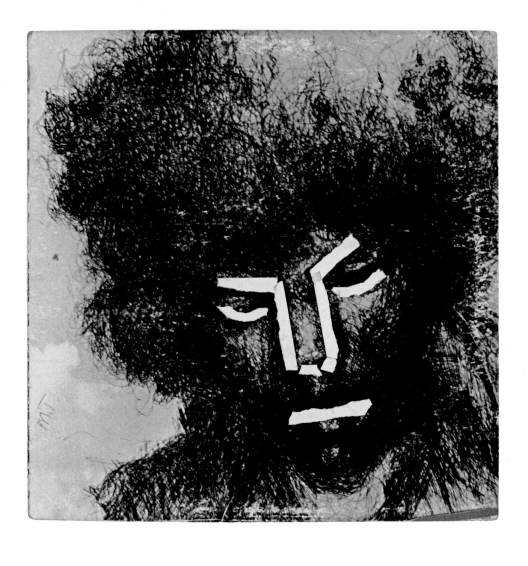

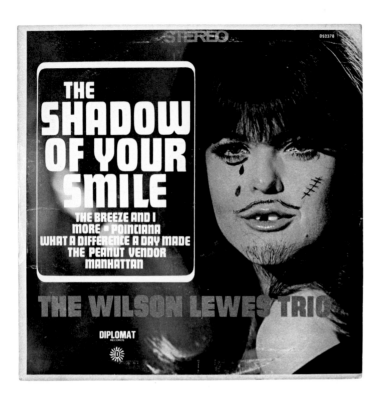

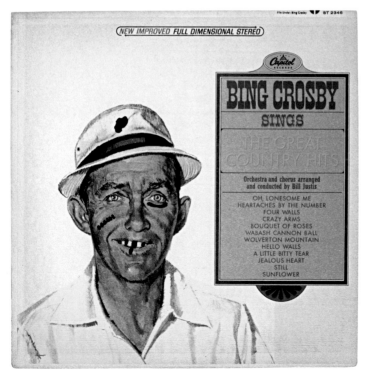

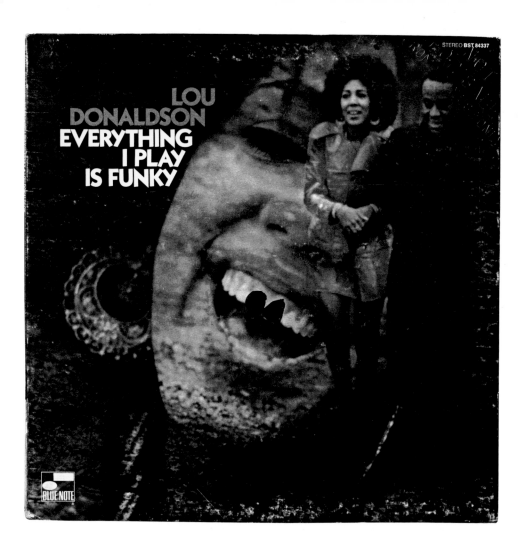

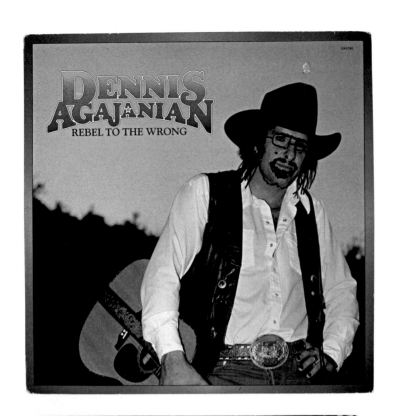

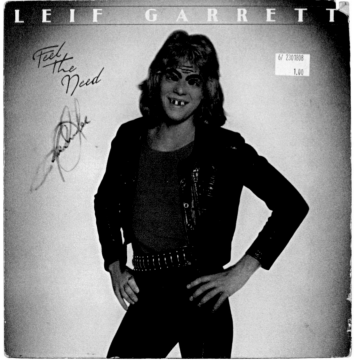

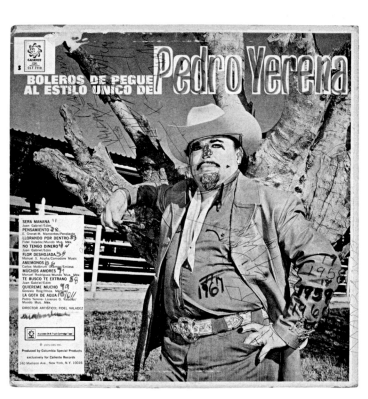

BOLEROS DE PEGUE
AL ESTILO UNICO DEL **Pedro Yerena**

SERA MANANA
Juan Gabriel/Edim
PENSAMIENTO
E. Grenet-M. Marrones/Peer
LLORANDO POR DENTRO
Fidel Valadez/Mundo Mus. Méx.
NO TENGO DINERO
Juan Gabriel/Edim
FLOR DESHOJADA
Manuel S. Acuña/Comadre Music
AMEMONOS
Carlos Motbrum/Comingo/Emlasa
MUCHOS AMORES
Manuel Rodriguez/Mundo Mus. Méx.
TE BUSCO TE EXTRANO
Juan Gabriel/Edim
QUIEREME MUCHO
Gonzalo Roig/Hnos. Marquez
LA GOTA DE AGUA
Pedro Yerena-Lorenzo G. Valadez/
Mundo Mus. Méx.

DIRECTOR ARTÍSTICO: FIDEL VALADEZ

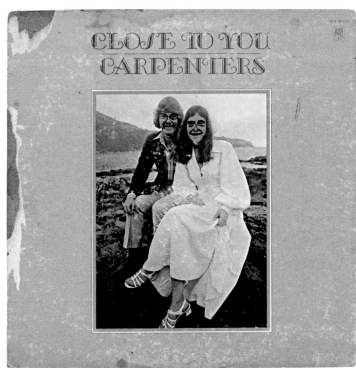

CLOSE TO YOU
CARPENTERS

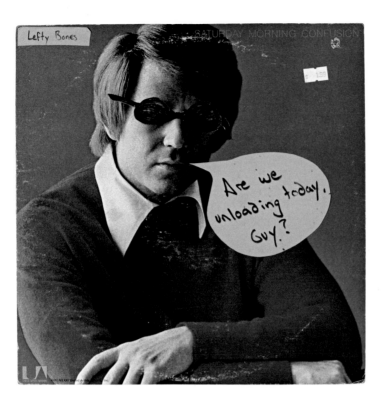

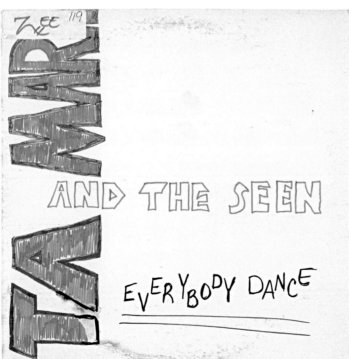

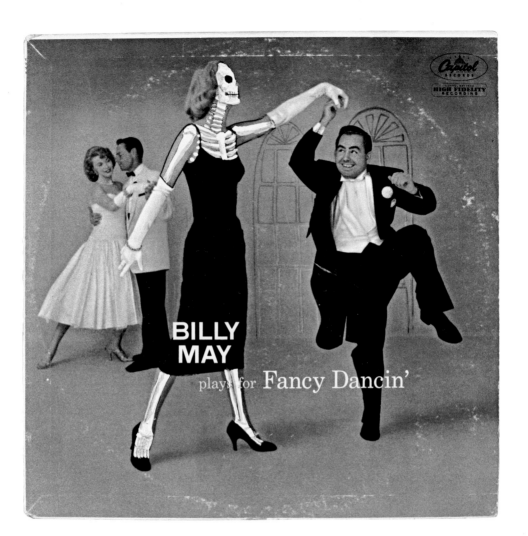

BILLY
MAY

plays for Fancy Dancin'

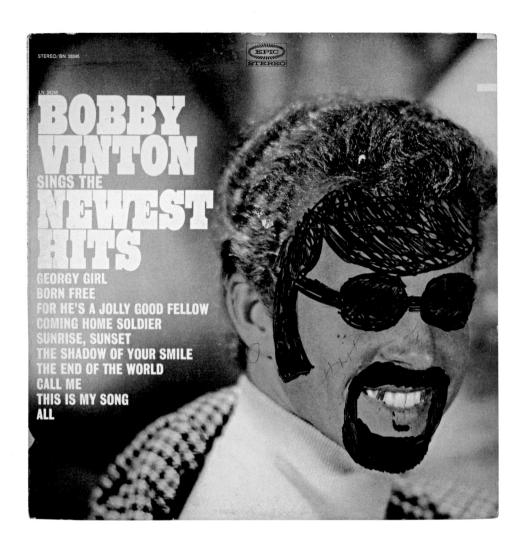

EPIC
STEREO

STEREO/BN 26245

LN 24245

BOBBY VINTON
SINGS THE
NEWEST HITS

GEORGY GIRL
BORN FREE
FOR HE'S A JOLLY GOOD FELLOW
COMING HOME SOLDIER
SUNRISE, SUNSET
THE SHADOW OF YOUR SMILE
THE END OF THE WORLD
CALL ME
THIS IS MY SONG
ALL

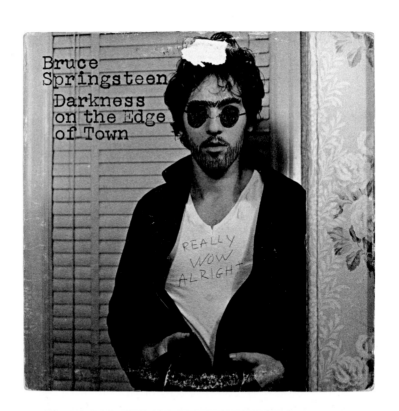

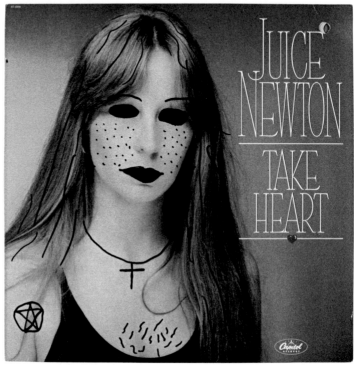

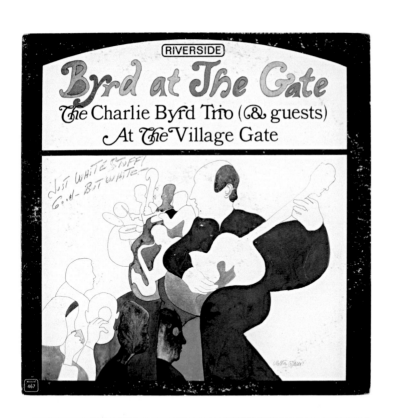

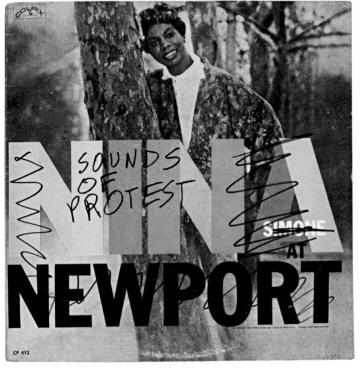

CHROME

Menstruation
is
Normal

THE VISITATION

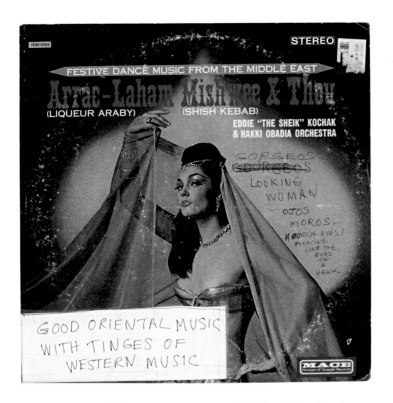

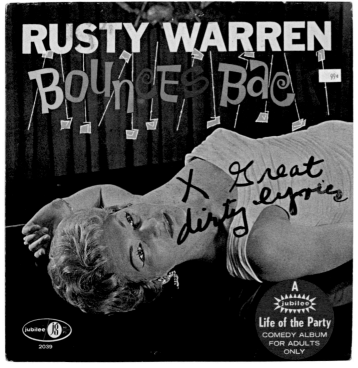

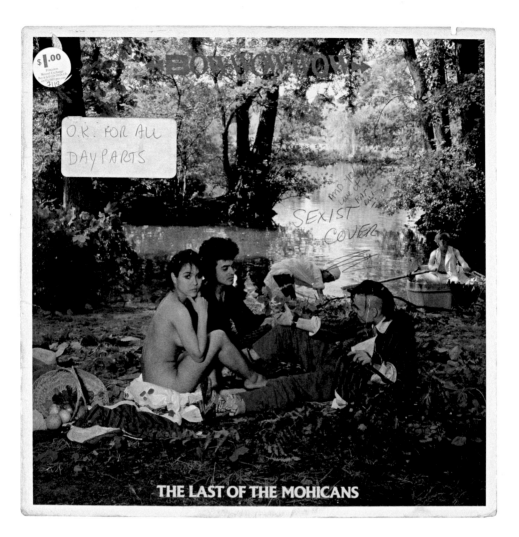

THE LAST OF THE MOHICANS

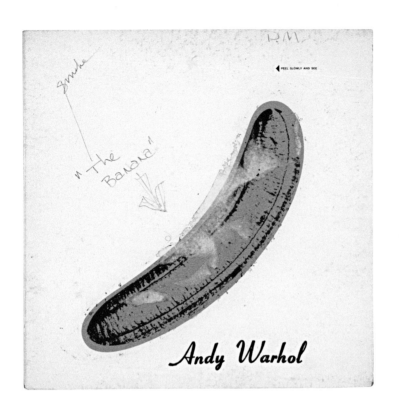

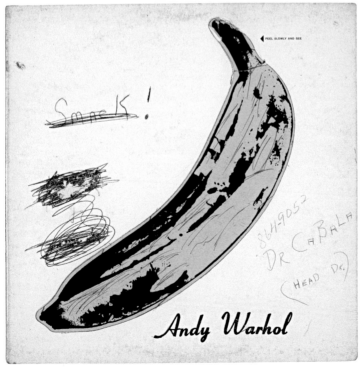

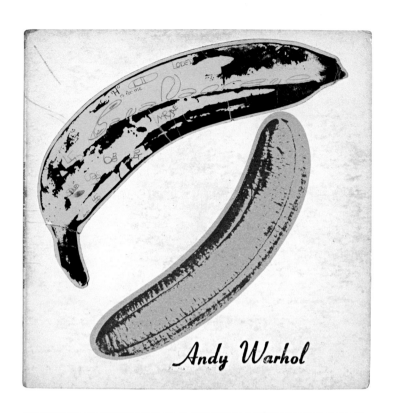

Andy Warhol

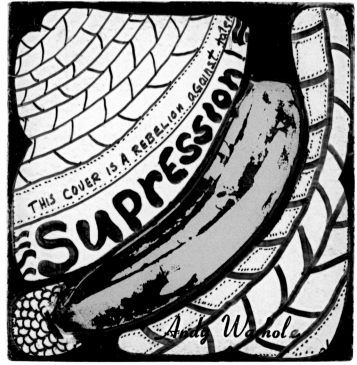

THIS COVER IS A REBELION AGAINST SUPRESSION

Andy Warhol

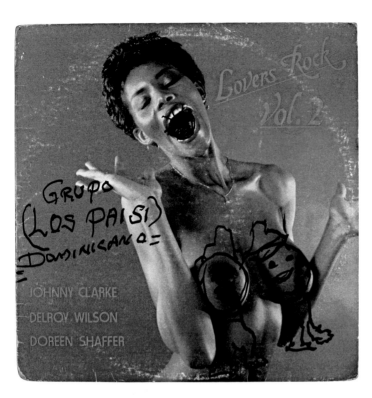

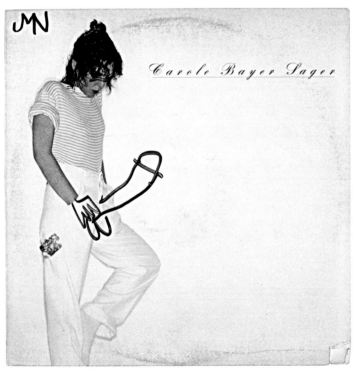

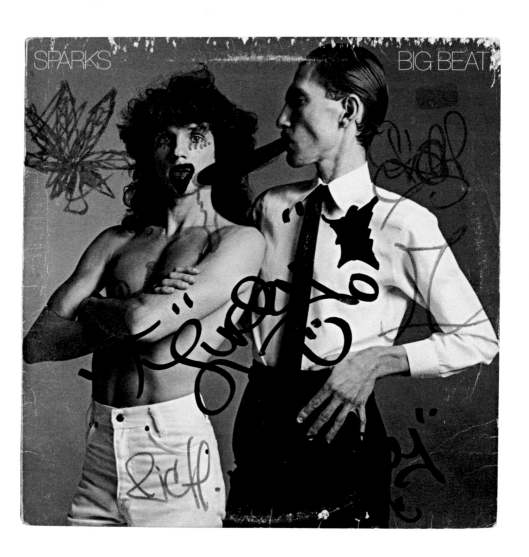

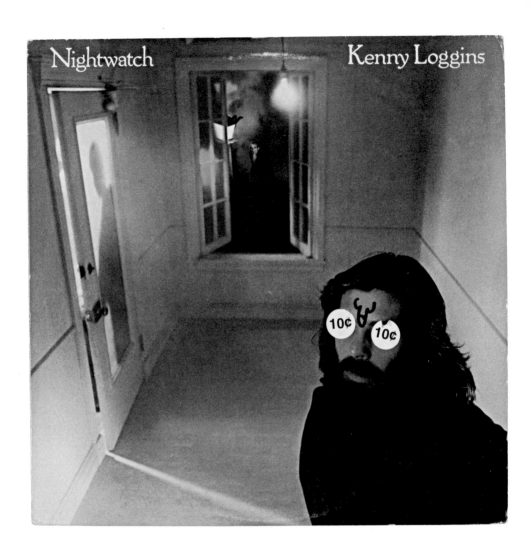

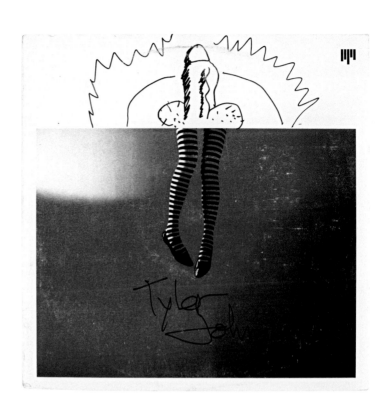

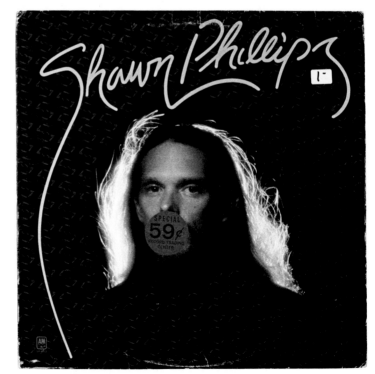

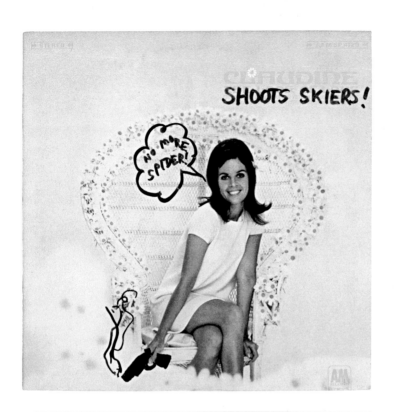

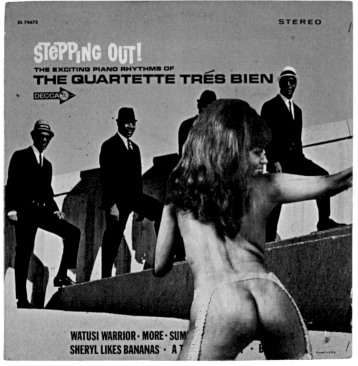

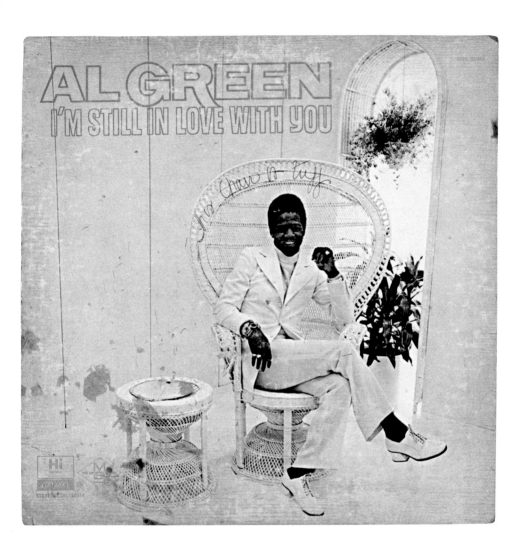

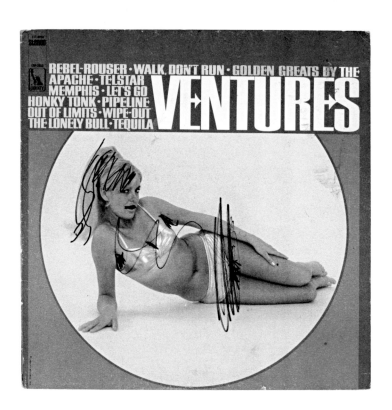

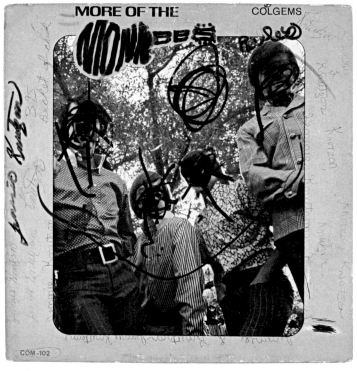

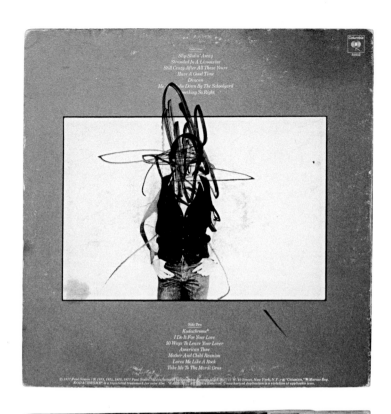

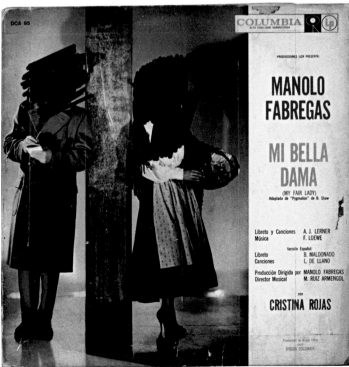

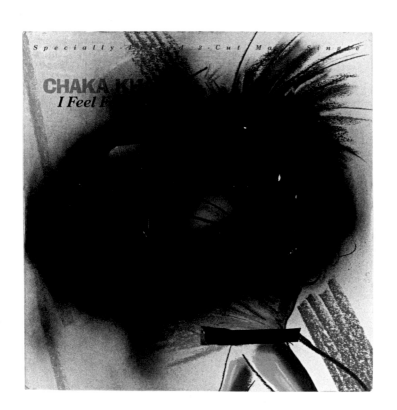

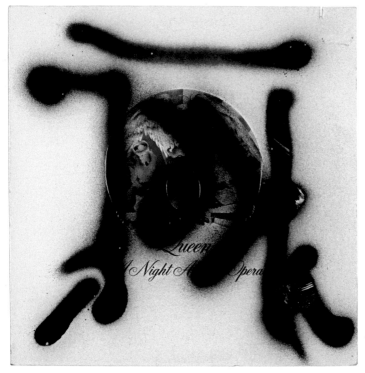

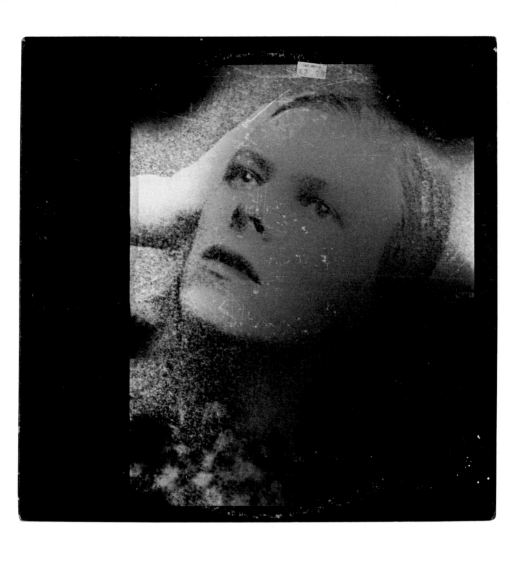

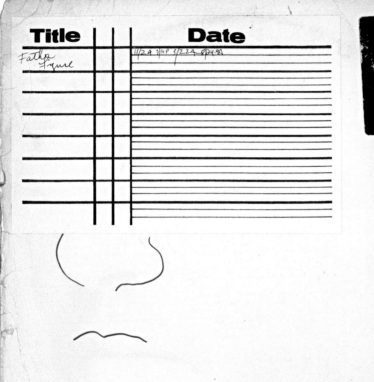

Title			Date
Father Figure			11/2 A 3/14 P 3/2 2A ⌀p4.9A

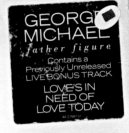

GEORGE
MICHAEL
father figure
Contains a
Previously Unreleased
LIVE BONUS TRACK
LOVE'S IN
NEED OF
LOVE TODAY
44 07587 S1

GEORGE
MICHAEL
~*father figure*

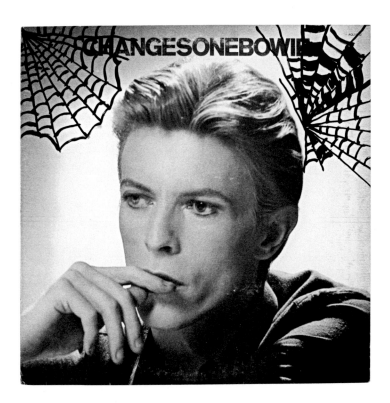

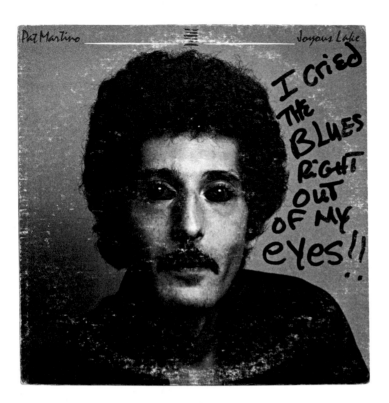

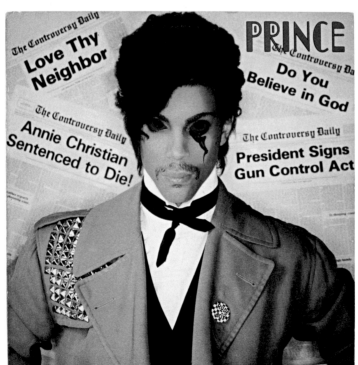

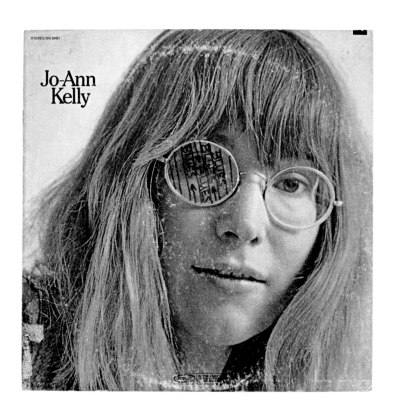

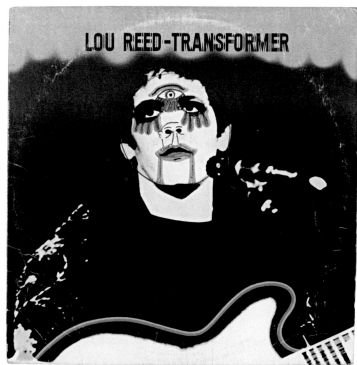

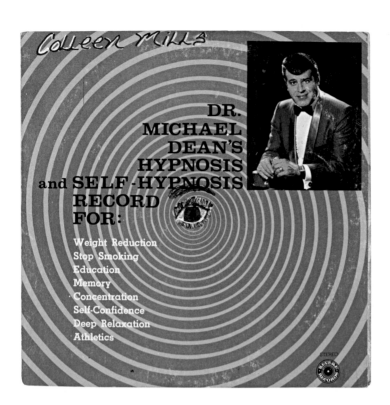

Colleen Mills

DR. MICHAEL DEAN'S HYPNOSIS and SELF-HYPNOSIS RECORD FOR:

Weight Reduction
Stop Smoking
Education
Memory
·Concentration
Self-Confidence
Deep Relaxation
Athletics

STEREO

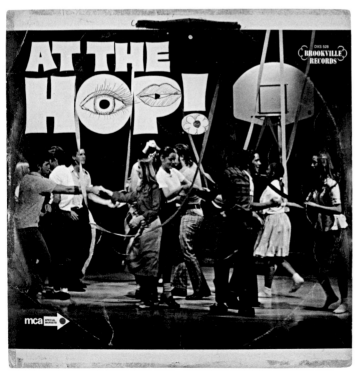

AT THE HOP!

DXS 528
BROOKVILLE RECORDS

mca SPECIAL MARKETS

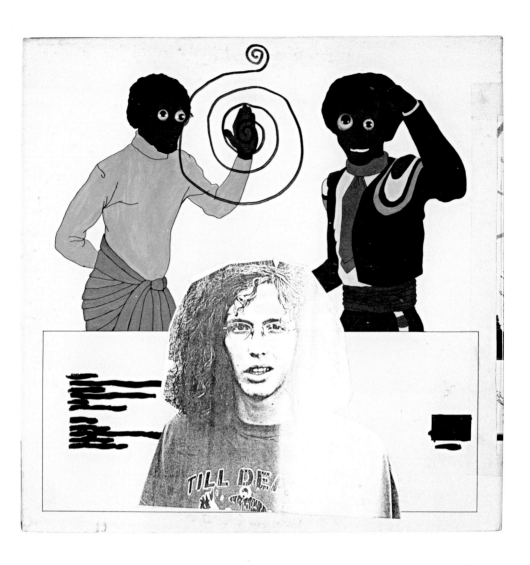

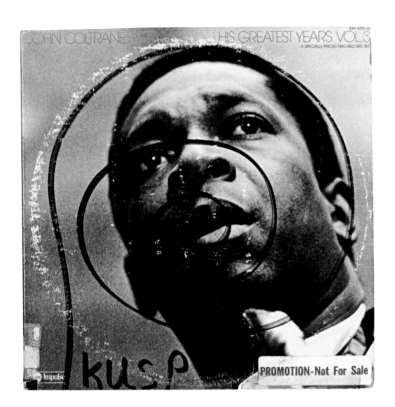

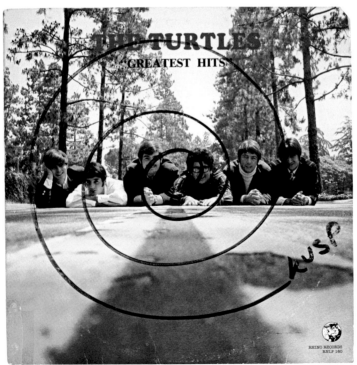

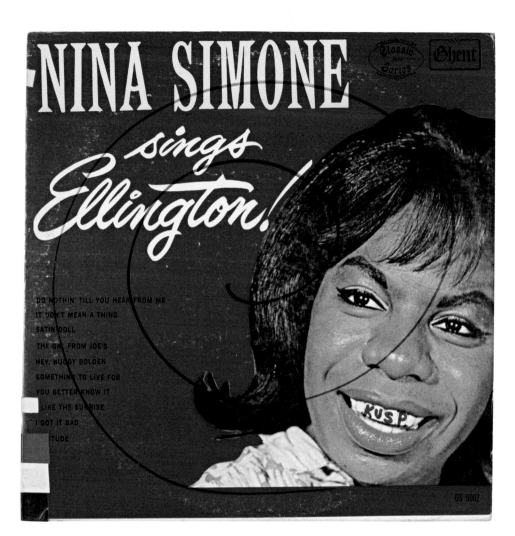

NINA SIMONE
sings
Ellington!

DO NOTHIN' TILL YOU HEAR FROM ME

IT DON'T MEAN A THING

SATIN DOLL

THE GAL FROM JOE'S

HEY, BUDDY BOLDEN

SOMETHING TO LIVE FOR

YOU BETTER KNOW IT

LIKE THE SUNRISE

I GOT IT BAD

ITUDE

Classic Jazz Series

Ghent

KUSP.

GS-5002

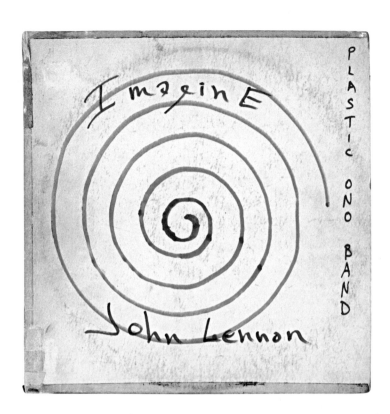

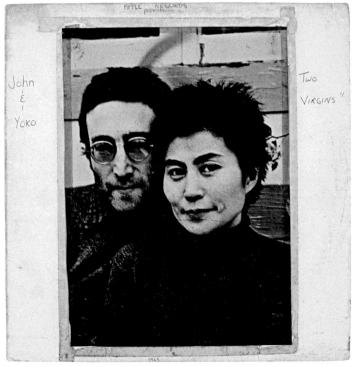

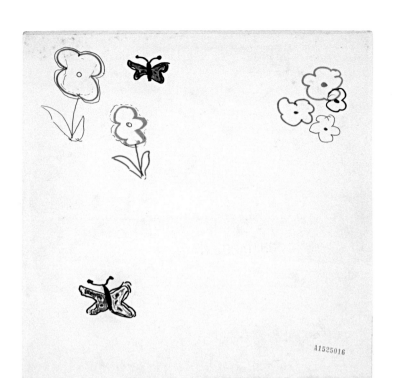

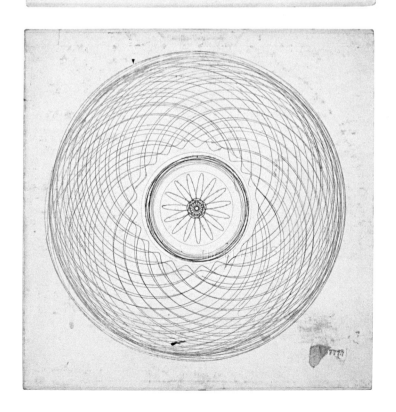

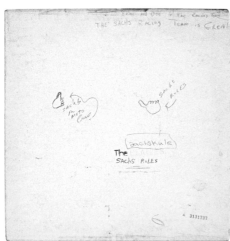

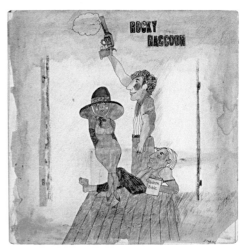

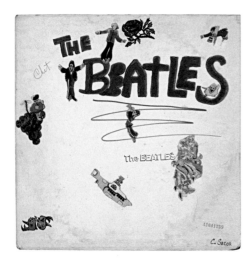

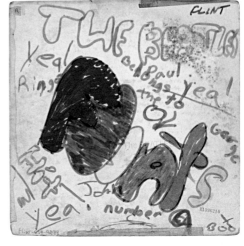

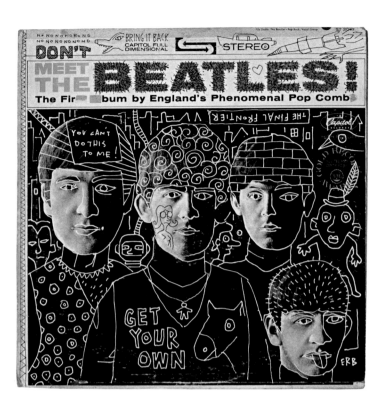

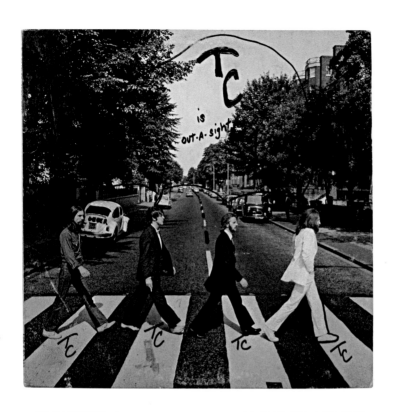

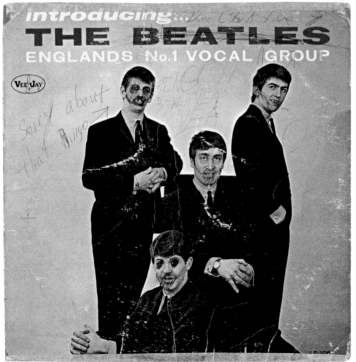

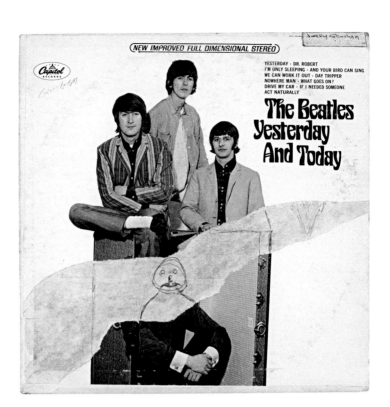

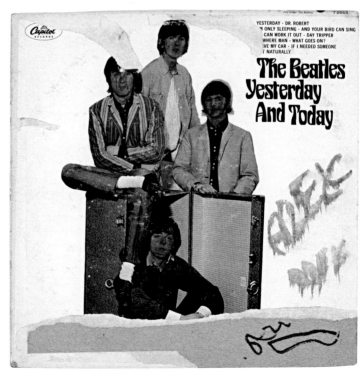

Peter Frampton

I'm In You

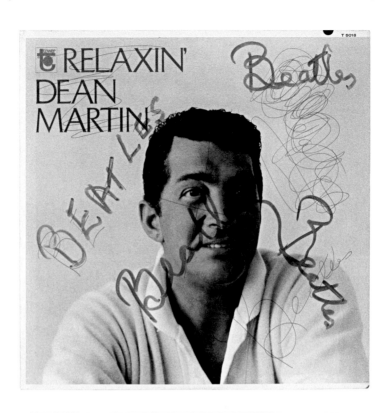

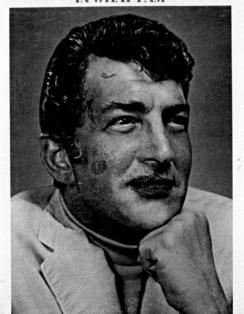

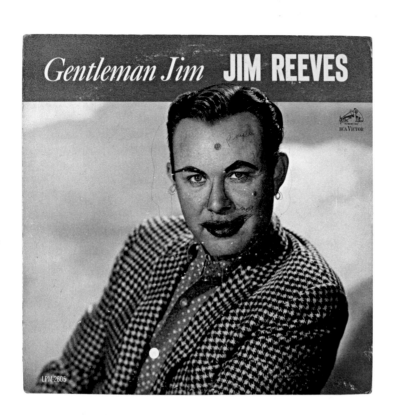

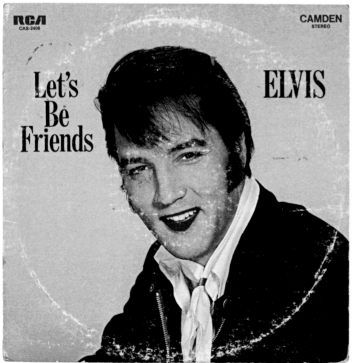

BRING IT ON HOME TO ME · HAVING A PARTY · YOU SEND ME ONLY SIXTEEN · EVERYBODY LOVES TO CHA CHA CHA · FOR SENTIMENTAL REASONS · WONDERFUL WORLD · SUMMERTIME CHAIN GANG · CUPID · TWISTIN' THE NIGHT AWAY · SAD MOOD

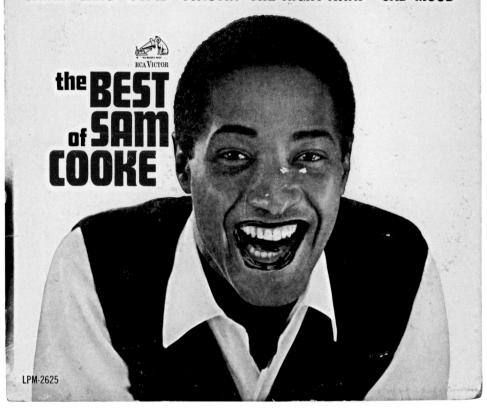

RCA VICTOR

the **BEST** of **SAM** **COOKE**

LPM-2625

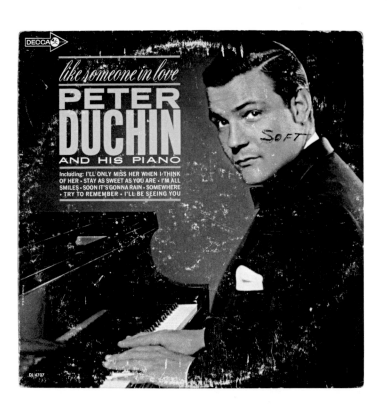

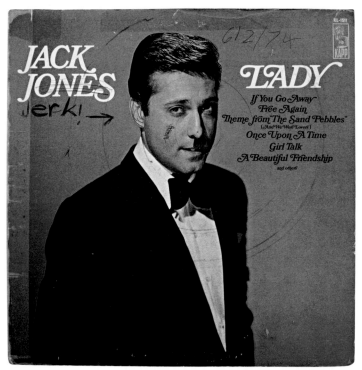

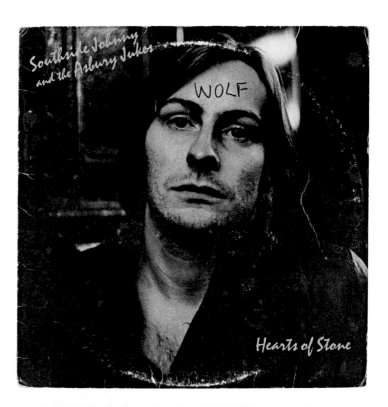

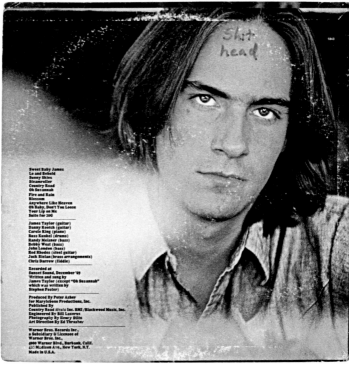

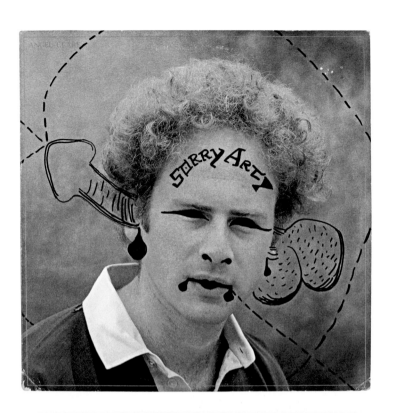

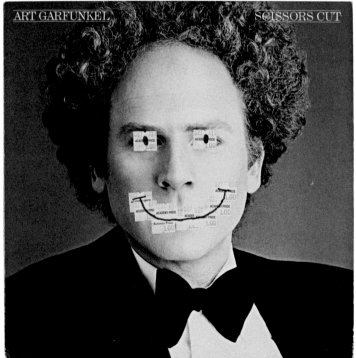

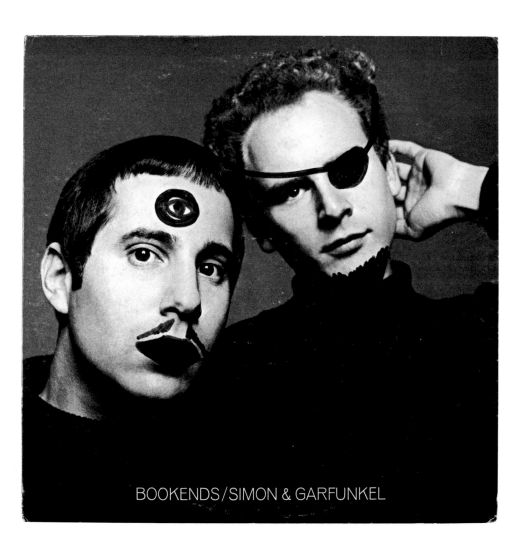

BOOKENDS/SIMON & GARFUNKEL

JOHNNY CASH
THE HOLY LAND

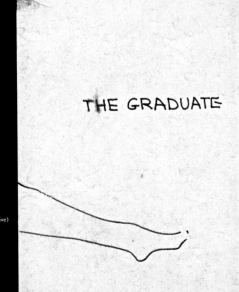

Prologue
Land Of Israel
A Mother's Love (Narrative)
This Is Nazareth
Nazarene
Town Of Cana (Narrative)
He Turned The Water Into Wine
My Wife June At Sea Of Galilee (Narrative)
Beautiful Words (Narrative)
Our Guide Jacob At Mount Tabor
The Ten Commandments
Daddy Sang Bass
At The Wailing Wall (Narrative)
Come To The Wailing Wall (Narrative)
In Bethlehem (Narrative)
In Garden Of Gethsemane (Narrative)
The Fourth Man
On The Via Dolorosa (Narrative)
Church Of The Holy Sepulchre (Narrative)
At Calvary (Narrative)
God Is Not Dead

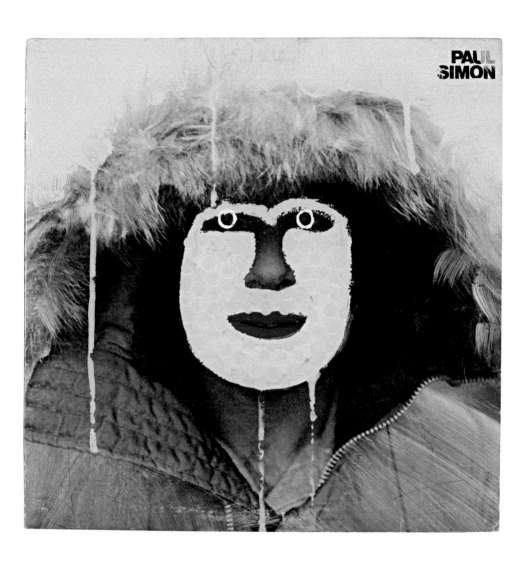

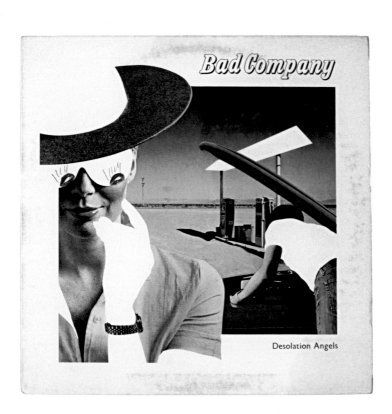

Bad Company

Desolation Angels

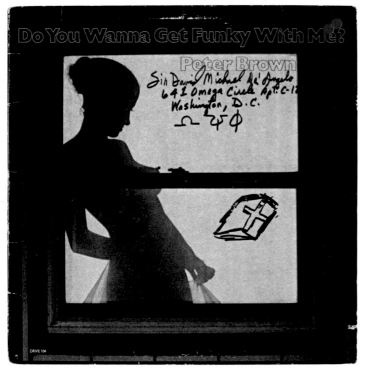

Do You Wanna Get Funky With Me?

Peter Brown

DRIVE 104

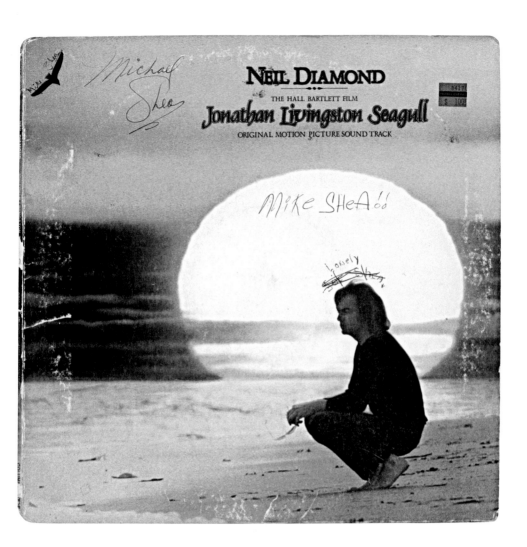

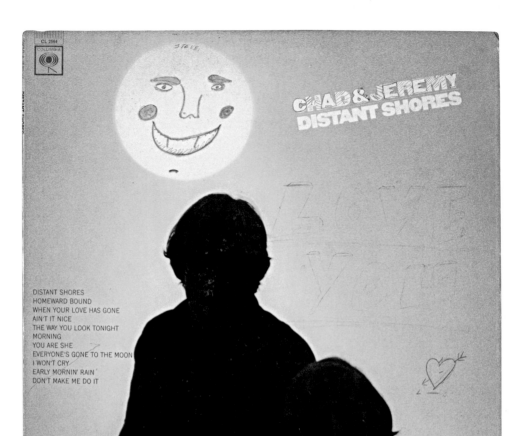

DISTANT SHORES
HOMEWARD BOUND
WHEN YOUR LOVE HAS GONE
AIN'T IT NICE
THE WAY YOU LOOK TONIGHT
MORNING
YOU ARE SHE
EVERYONE'S GONE TO THE MOON
I WON'T CRY
EARLY MORNIN' RAIN
DON'T MAKE ME DO IT

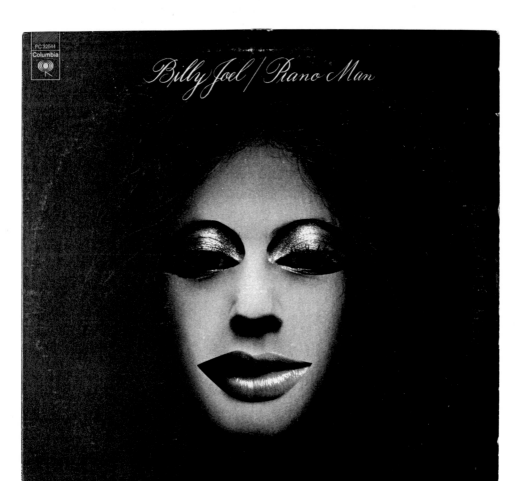

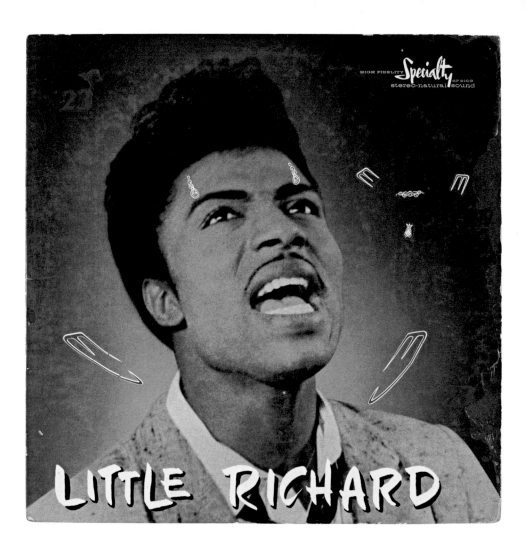

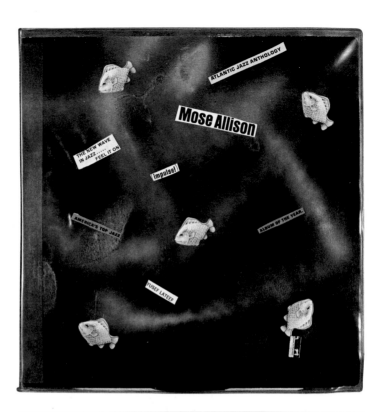

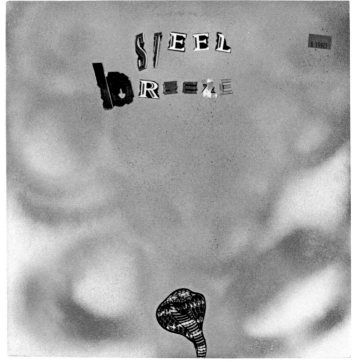

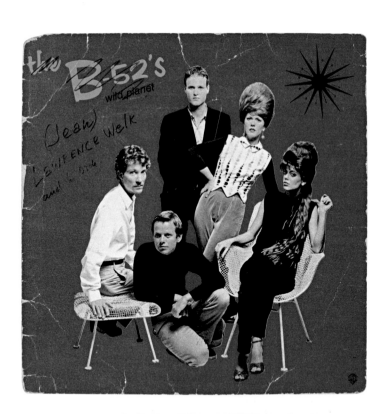

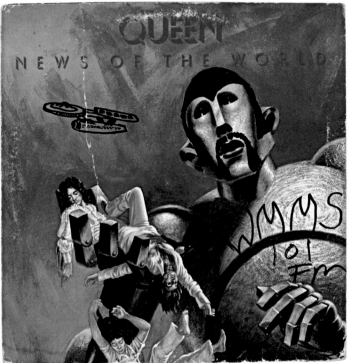

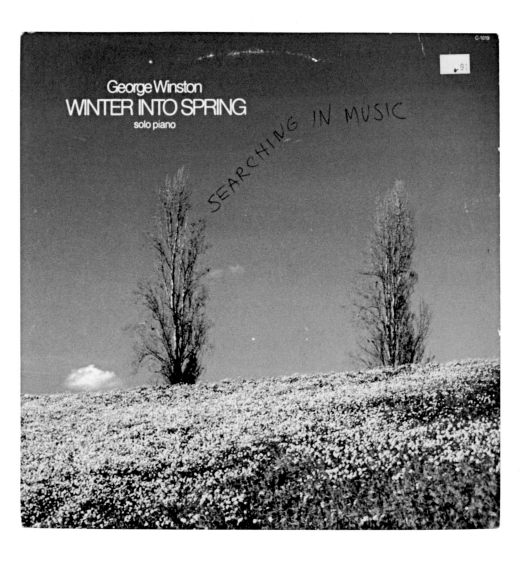

George Winston
WINTER INTO SPRING
solo piano

SEARCHING IN MUSIC

C-1019

91

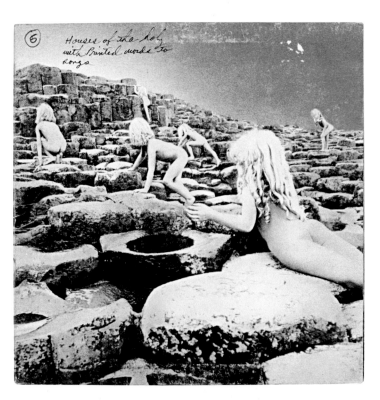

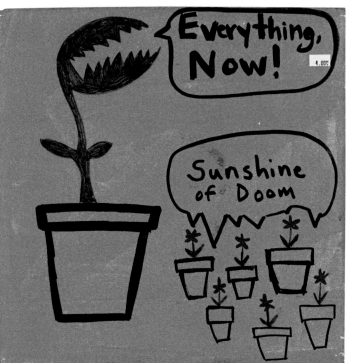

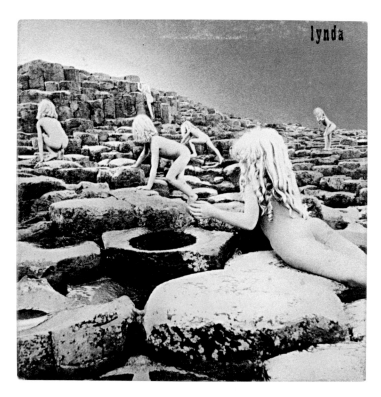

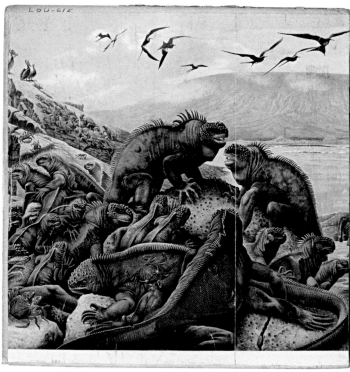

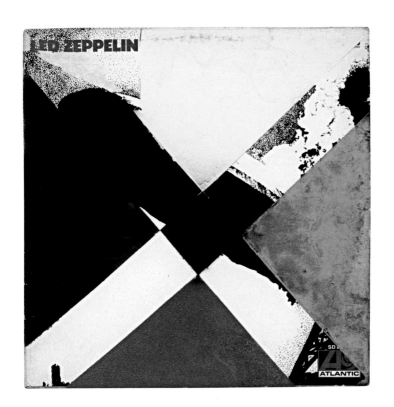

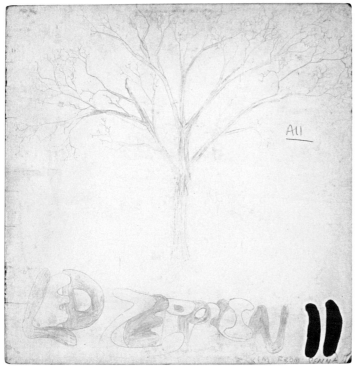

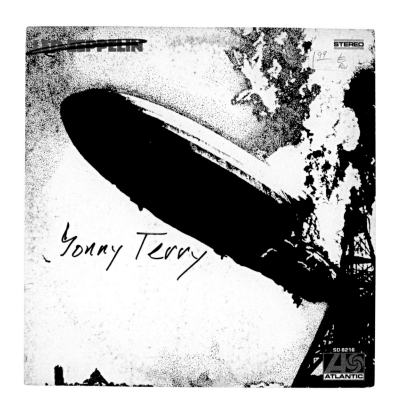

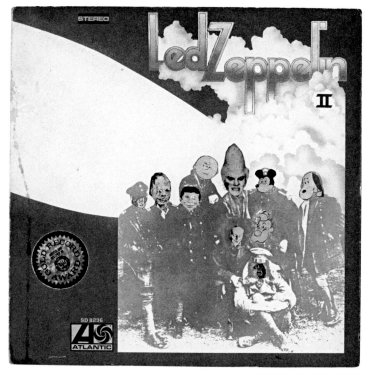

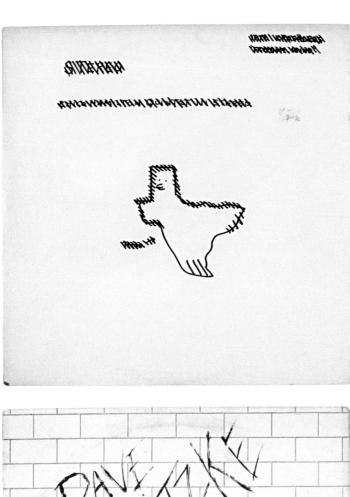

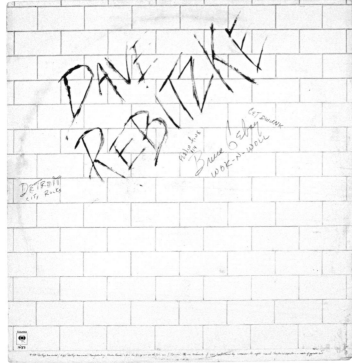

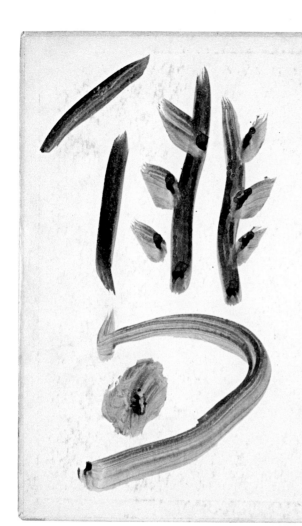

HAIKU

Alan Watts

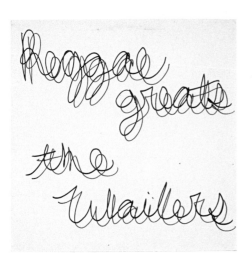

Reggae greats the Wailers

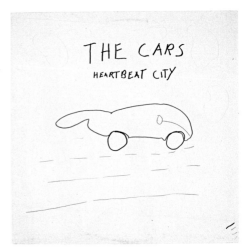

THE CARS
HEARTBEAT CITY

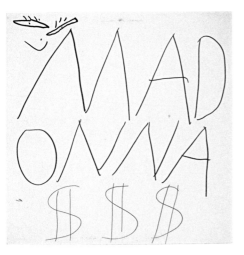

MAD ONNA $$$

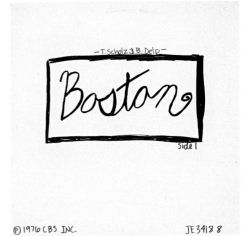

—T. Scholz & B. Delp—
Boston
side 1

℗ 1976 CBS INC. JE 34188

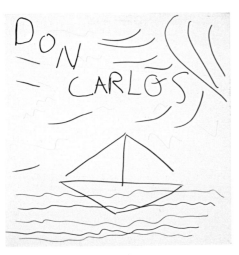

DON CARLOS

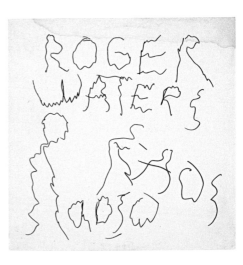

ROGER WATERS

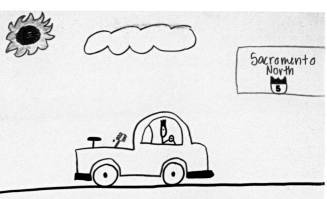

Frankie Goss
TO
Hollywood

The Pleasure dome

Side 1&2

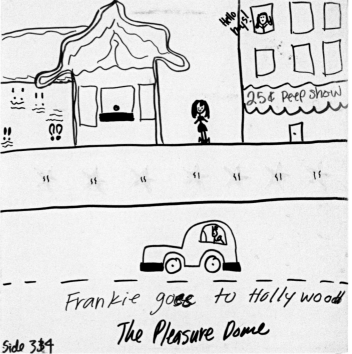

Frankie goss to Hollywood
The Pleasure Dome

Side 3&4

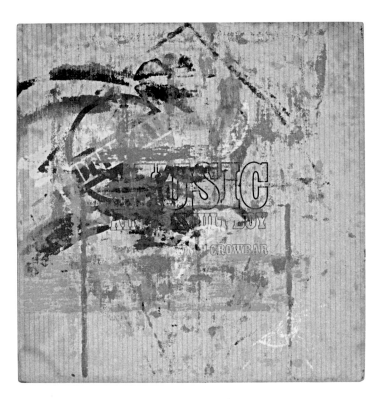

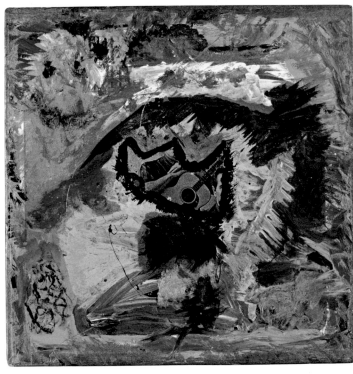

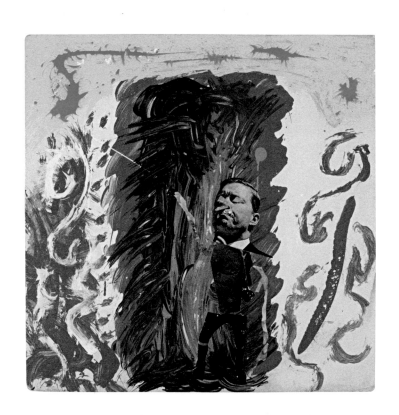

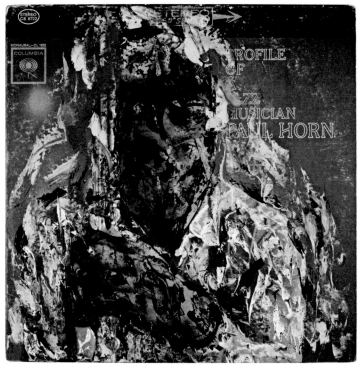

ROFILE
OF
MUSICIAN
PAUL HORN

STEREO
CS 8722

MONAURAL—CL 1922

COLUMBIA

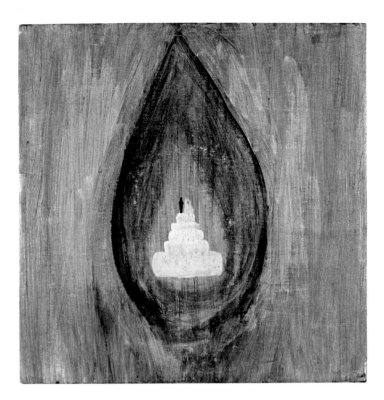

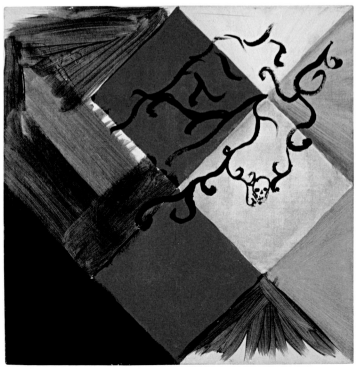

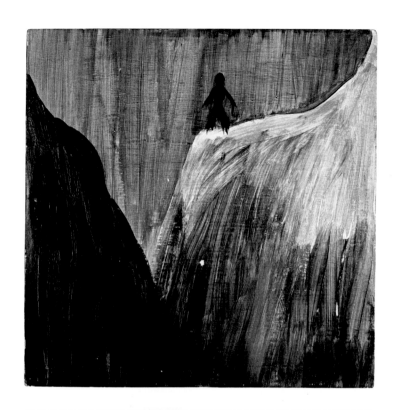

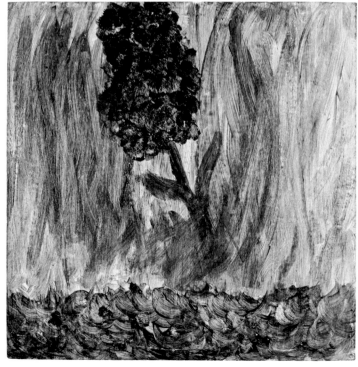

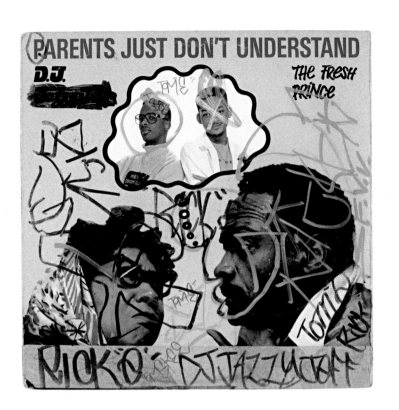

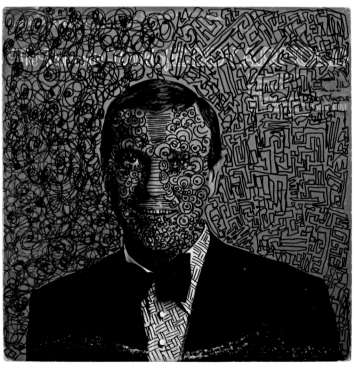

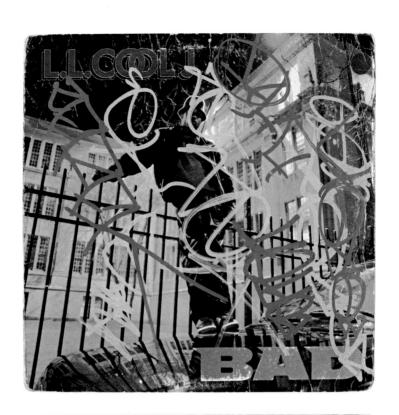

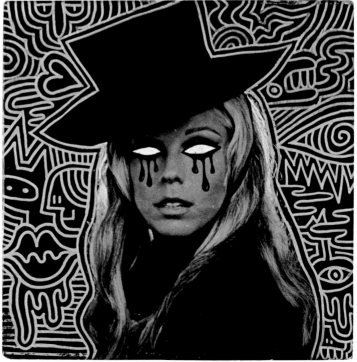

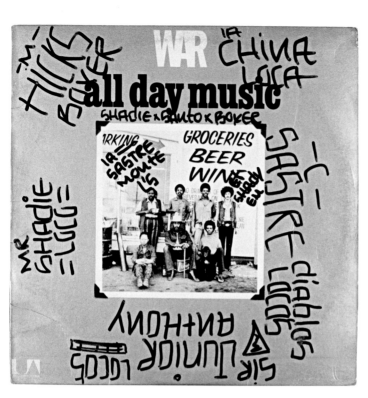

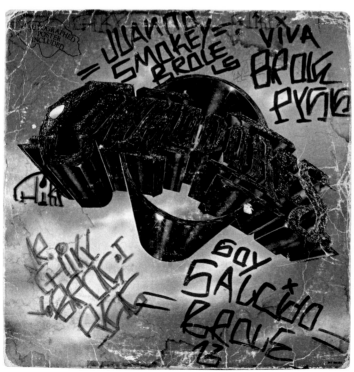

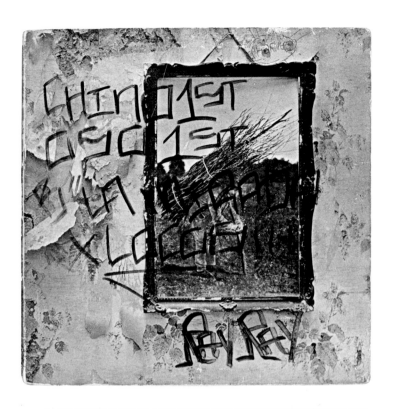

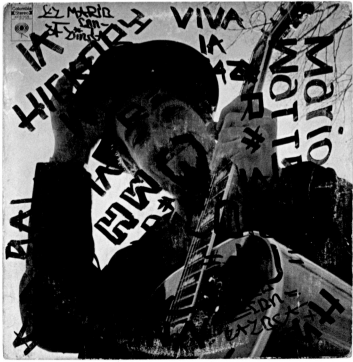

Art Blakey
and the Jazz Messengers*
FREE FOR ALL

Side One 1. Free For All
 2. Hammer Head

Side Two 1. The Core
 2. Pensativa

 * Freddie Hubbard, Wayne Shorter
 Cedar Walton, Curtis Fuller
 Reggie Workman

PULL UP THE BUSHES

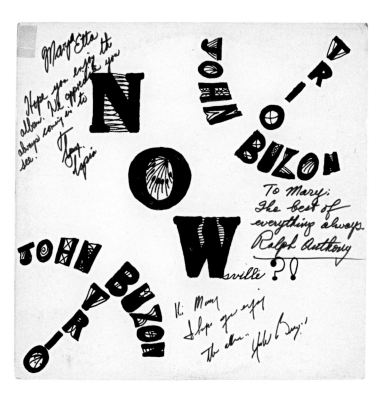

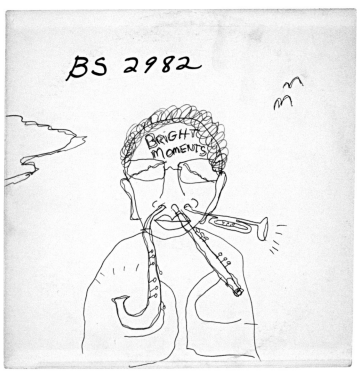

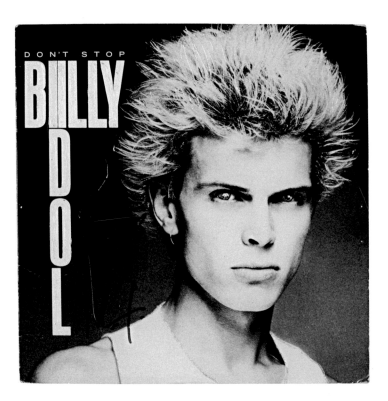

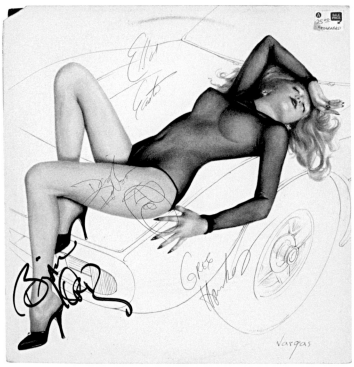

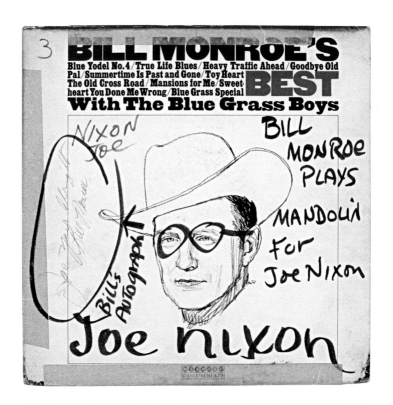

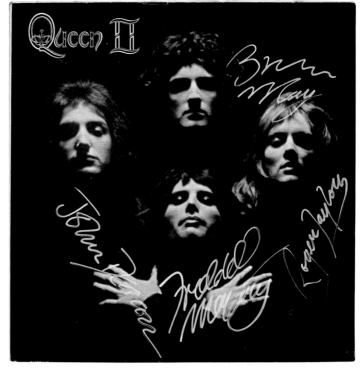

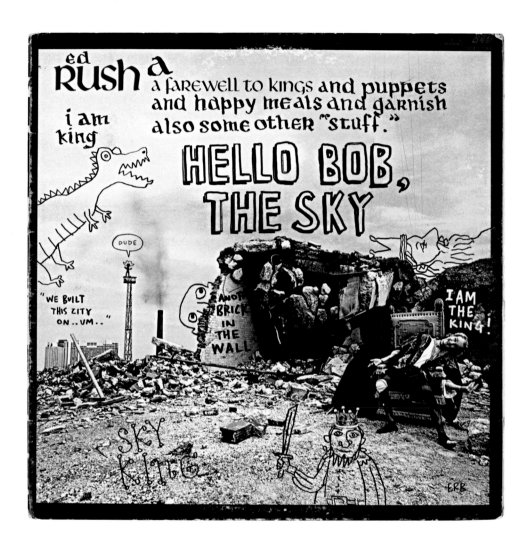

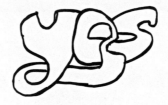

CLOSE TO The
Edge

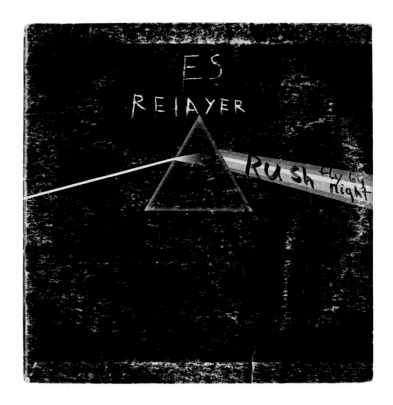

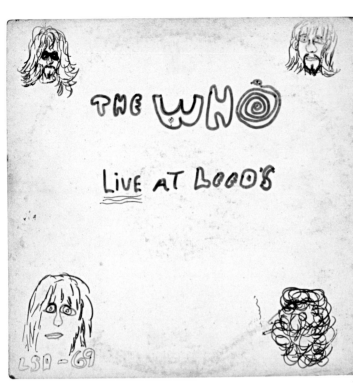

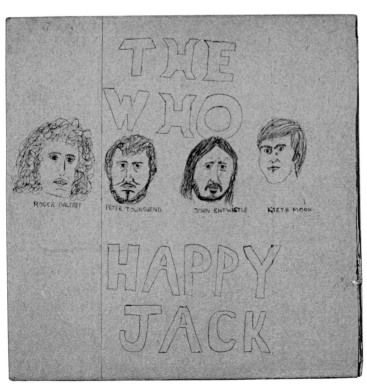

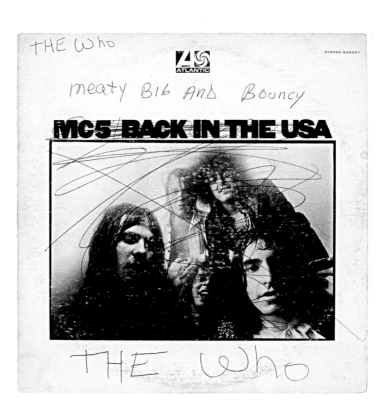

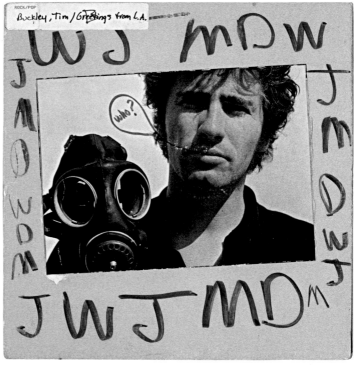

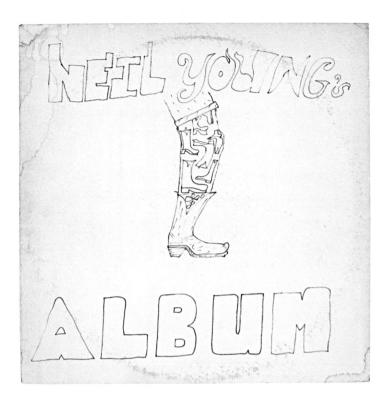

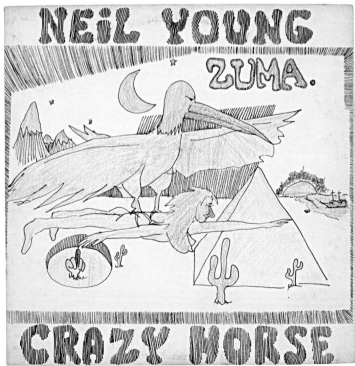

NEIL Young—After the Gold Rush

BLIND FAITH

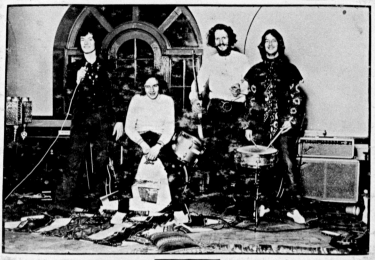

ATCO

**ERIC
CLAPTON
STEVE
WINWOOD
GINGER
BAKER
RICK
GRECH**

CROSBY, STILLS & NASH

" NO - TALENT
HAS - BEENS "
VOL. III

CROSBY, STILLS & NASH

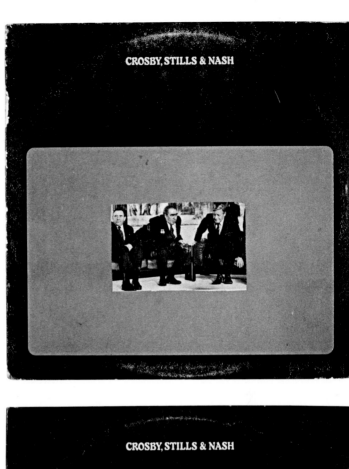

CROSBY, STILLS & NASH

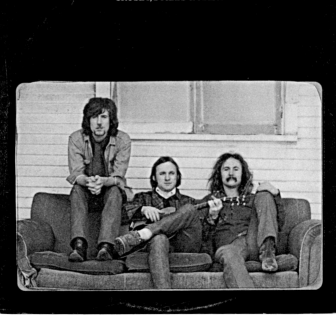

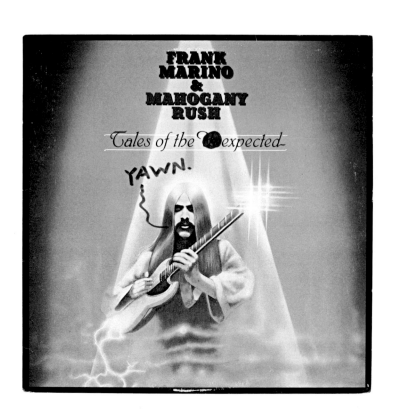

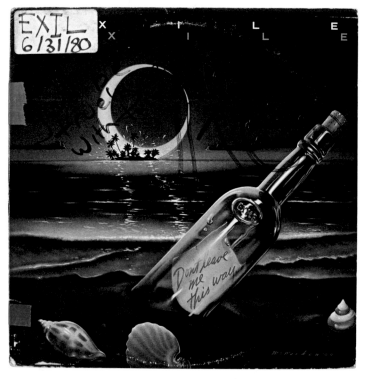

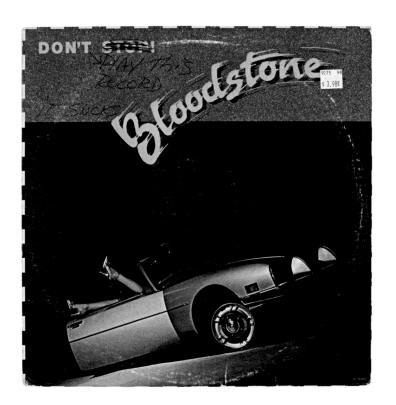

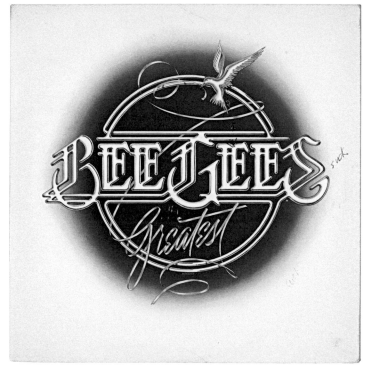

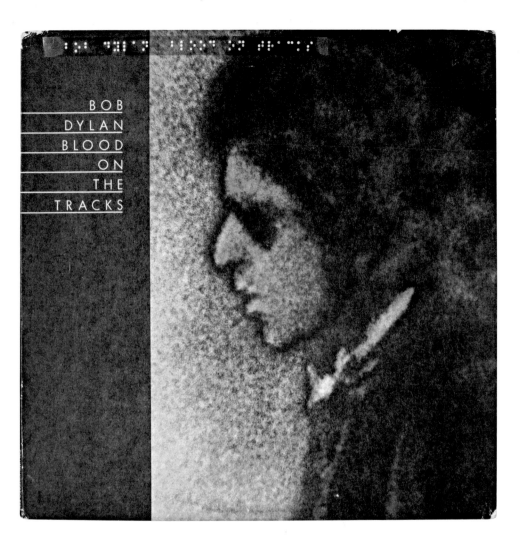

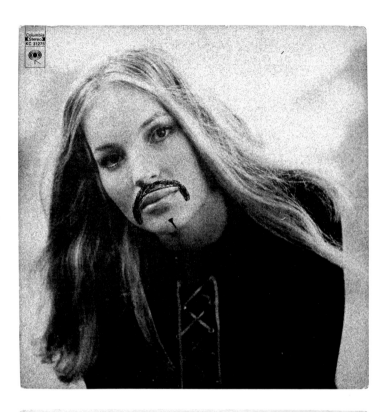

1750 Arch Records S-1787

New Music for Harp

CAG·3

FEATURED
1 Cage 4-26-83
2 Cage 12-24-92

works by:
Roger Bourland
John Cage
Ruth Lomon
William Thomas McKinley
George Rochberg

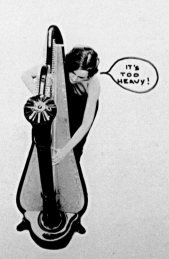

Susan Allen, harp

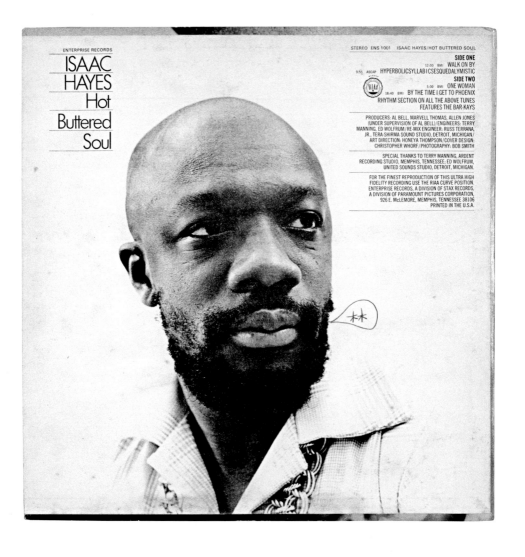

ENTERPRISE RECORDS

ISAAC HAYES Hot Buttered Soul

STEREO ENS 1001 ISAAC HAYES/HOT BUTTERED SOUL

SIDE ONE
12:00 BMI WALK ON BY
9:51 ASCAP HYPERBOLICSYLLABICSESQUEDALYMISTIC
SIDE TWO
5:00 BMI ONE WOMAN
18:40 BMI BY THE TIME I GET TO PHOENIX
RHYTHM SECTION ON ALL THE ABOVE TUNES
FEATURES THE BAR-KAYS

PRODUCERS: AL BELL, MARVELL THOMAS, ALLEN JONES
(UNDER SUPERVISION OF AL BELL)/ENGINEERS: TERRY
MANNING, ED WOLFRUM/RE-MIX ENGINEER: RUSS TERRANA,
JR., TERA-SHIRMA SOUND STUDIO, DETROIT, MICHIGAN/
ART DIRECTION: HONEYA THOMPSON/COVER DESIGN:
CHRISTOPHER WHORF/PHOTOGRAPHY: BOB SMITH

SPECIAL THANKS TO TERRY MANNING, ARDENT
RECORDING STUDIO, MEMPHIS, TENNESSEE; ED WOLFRUM,
UNITED SOUNDS STUDIO, DETROIT, MICHIGAN.

FOR THE FINEST REPRODUCTION OF THIS ULTRA HIGH
FIDELITY RECORDING USE THE RIAA CURVE POSITION.
ENTERPRISE RECORDS, A DIVISION OF STAX RECORDS,
A DIVISION OF PARAMOUNT PICTURES CORPORATION,
926 E. McLEMORE, MEMPHIS, TENNESSEE 38106
PRINTED IN THE U.S.A.

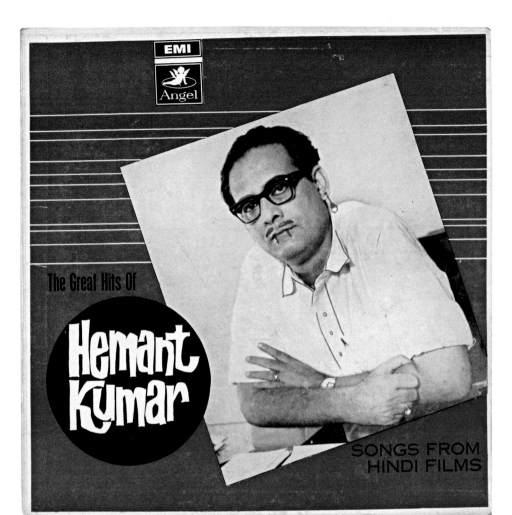

EMI

Angel

The Great Hits Of

Hemant Kumar

SONGS FROM
HINDI FILMS

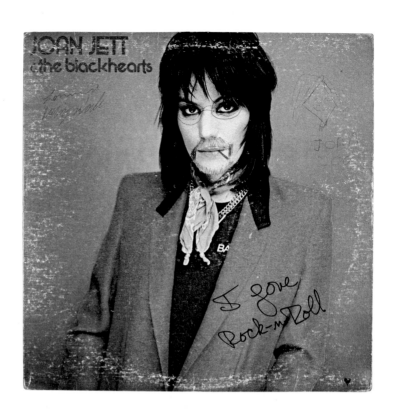

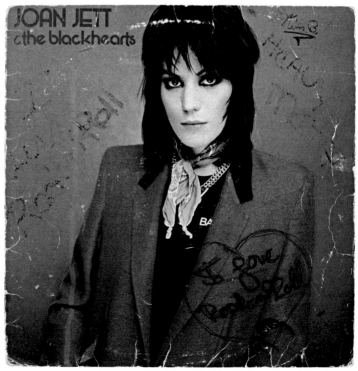

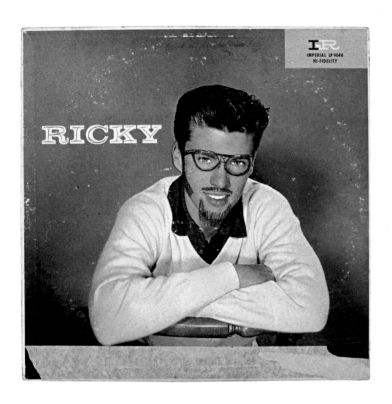

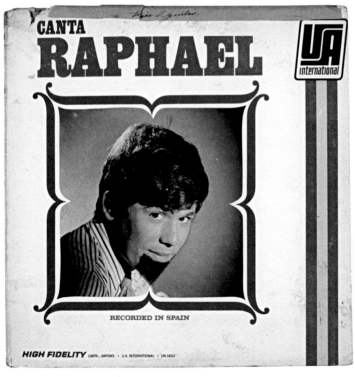

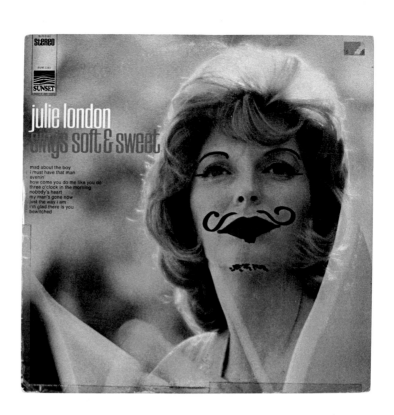

STEREO

SUNSET

julie london
sings soft & sweet

mad about the boy
i must have that man
evenin'
how come you do me like you do
three o'clock in the morning
nobody's heart
my man's gone now
just the way i am
i'm glad there is you
bewitched

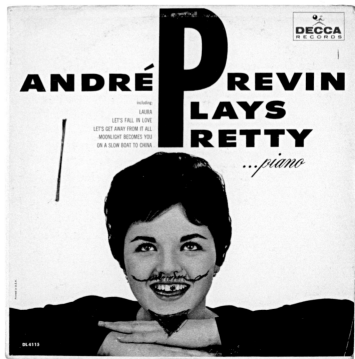

DECCA
RECORDS

ANDRÉ **P**REVIN

including:

LAURA
LET'S FALL IN LOVE
LET'S GET AWAY FROM IT ALL
MOONLIGHT BECOMES YOU
ON A SLOW BOAT TO CHINA

PLAYS
PRETTY
...piano

DL 4115

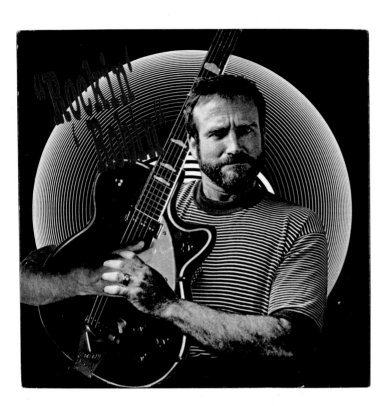

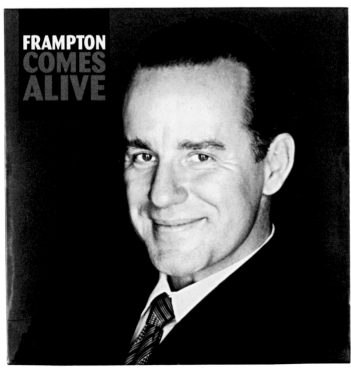

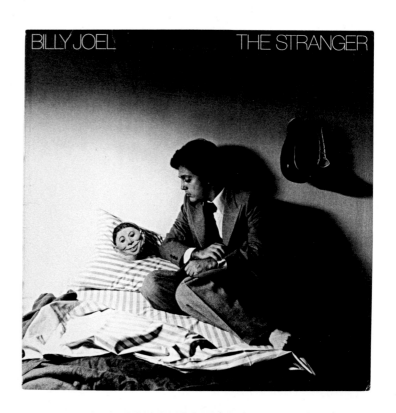

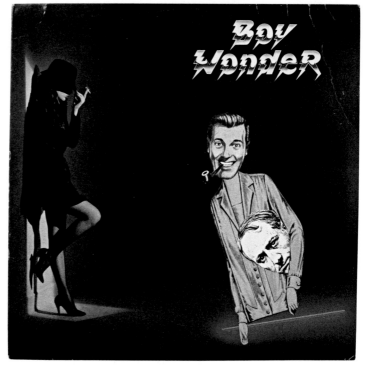

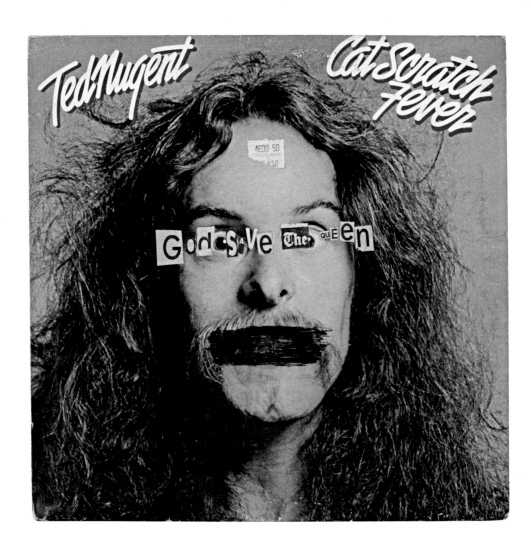

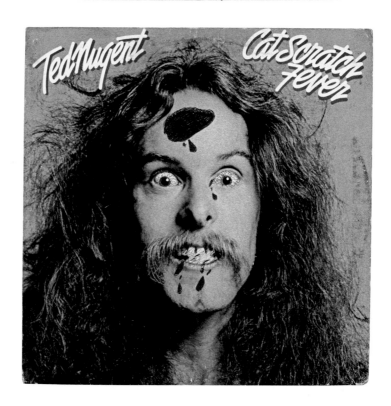

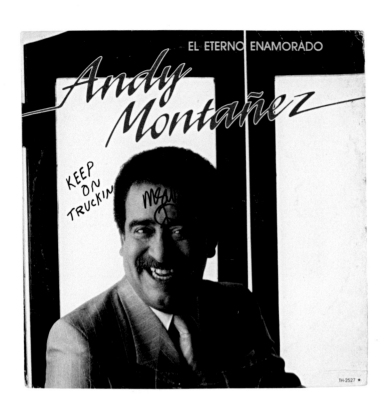

EL ETERNO ENAMORADO

Andy Montañez

KEEP ON TRUCKIN

TH-2527

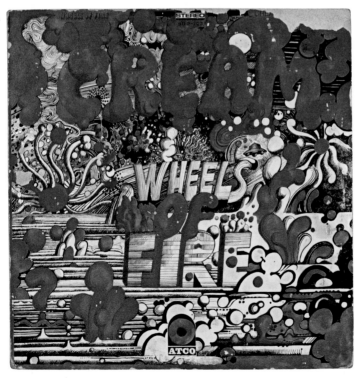

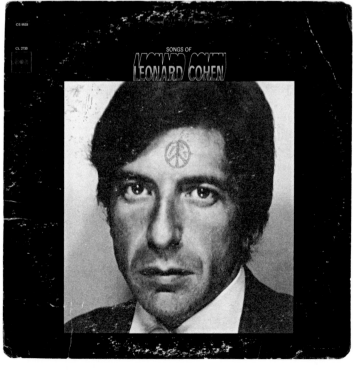

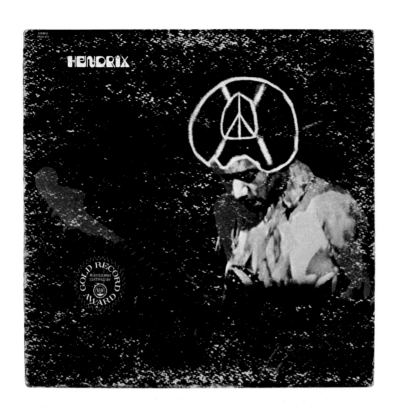

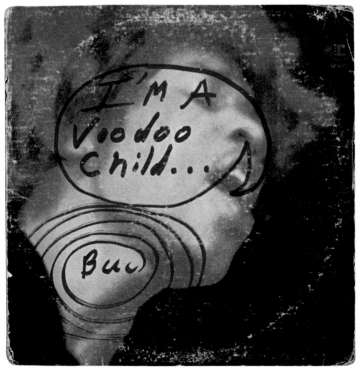

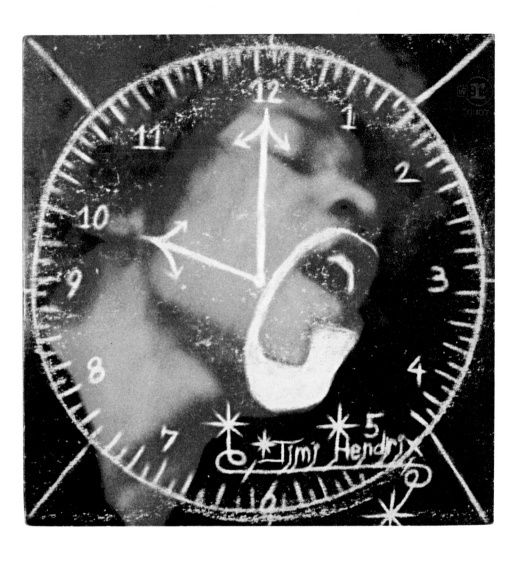

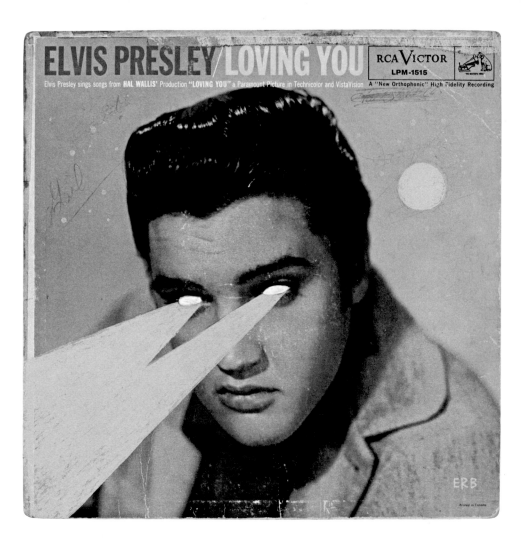

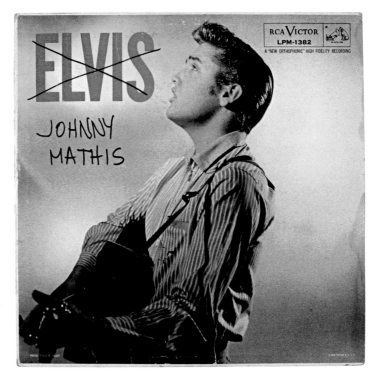

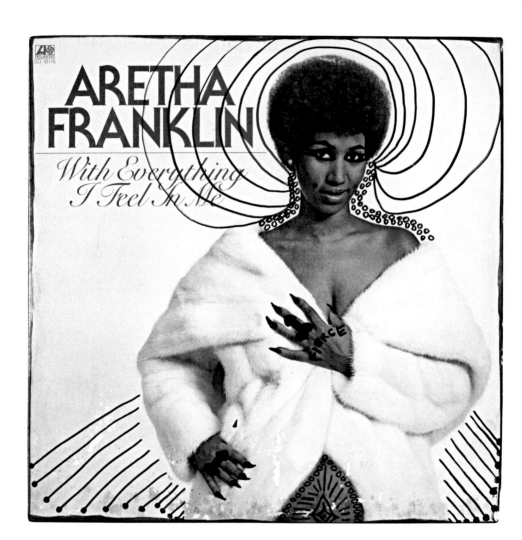

Queen
A Night At The Opera

Best Wishes
Bill Funk

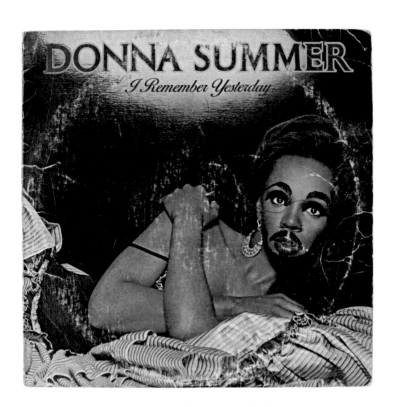

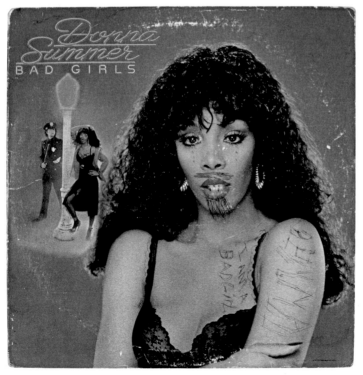

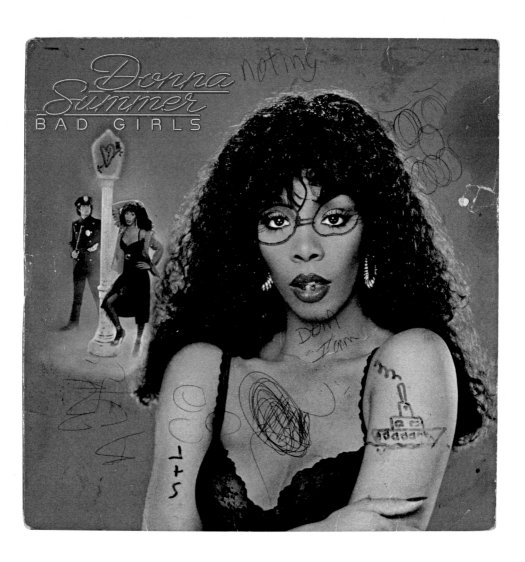

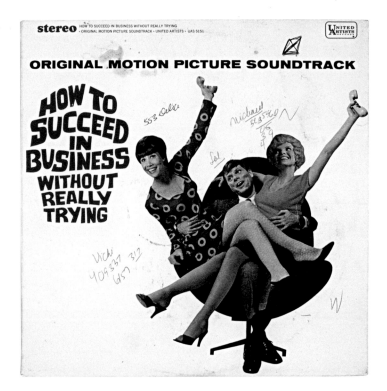

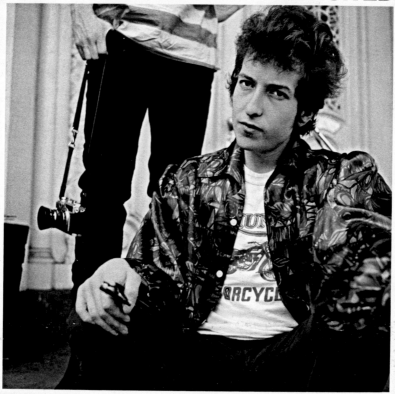

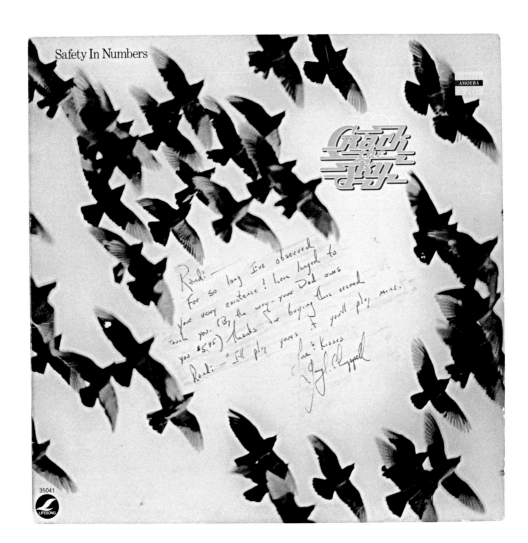

Safety In Numbers

35041

LIFESONG

AMOEBA

Randi —
For so long I've observed
your very existence & have longed to
touch you. (By the way - your Dad owes
you $5.95) Thanks for buying this record
Randi — "I'll play yours & you'll play mine.
Love & Kisses
Gary S. Chappell

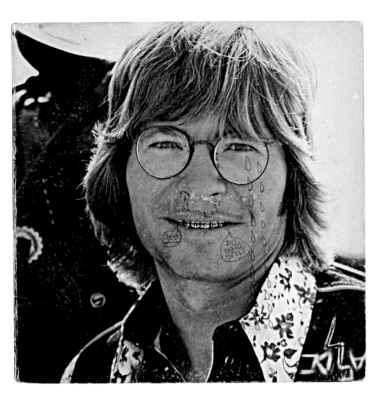

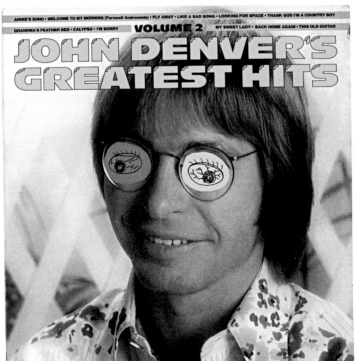

ANNIE'S SONG • WELCOME TO MY MORNING (Farewell Andromeda) • FLY AWAY • LIKE A SAD SONG • LOOKING FOR SPACE • THANK GOD I'M A COUNTRY BOY
GRANDMA'S FEATHER BED • CALYPSO • I'M SORRY VOLUME 2 MY SWEET LADY • BACK HOME AGAIN • THIS OLD GUITAR

JOHN DENVER'S GREATEST HITS

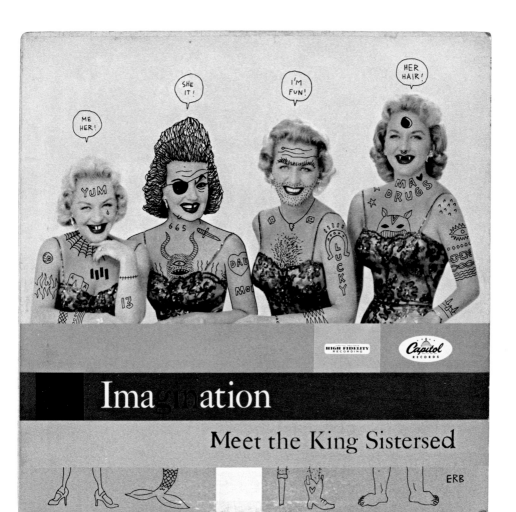

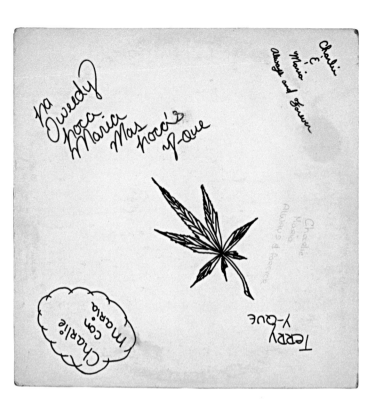

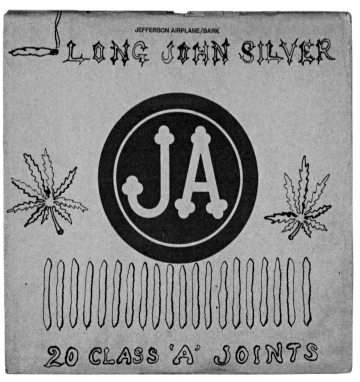

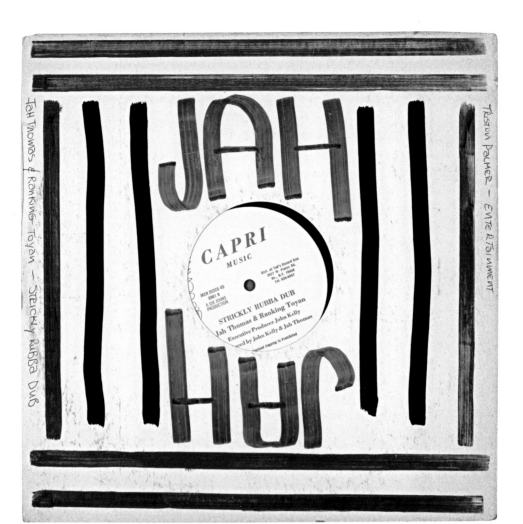

LINER NOTES

I look for stuff—stuff that I love. It's something I've always done, trying to find that thing that feels special to me—unusual, beautiful... maybe both? I can't deny there's some compulsion in my wiring. I desire the dopamine rush that comes with "the score." But I like to think of it as the "good compulsion"—compulsion for fun (and sometimes profit)! This process is second nature to me by now, after decades of hunting. It's also strangely meditative—sort of feels like an exercise in not seeing things and instead, the art of allowing that special find to find me. There's so much stuff in the world! I'm glad I can feel what's meant for me. Rocks, baseball cards, Hot Wheels, guitars, books, art, chairs and records... oh, records! They're big for me again, having first collected as a teenager. The move to Los Angeles and the friends I made here inspired my renaissance of collecting vinyl. Beyond the fetishistic aspect of collecting records as objects (objects compressed with immeasurable creative expression), music has been a constant in my life—listening, writing, playing and collecting.

This "defaced" collection has allowed several of my passions to collide. I can remember the thrill of the first find—Amoeba Records, "Staff Picks" bin. It jumped out at me! Jefferson Airplane's "Bark" LP, in that cool, brown paper sleeve cover. It was radically altered with the addition of meticulous hand-drawn marijuana leaves and rows of joints. There was a Post-It note on it from the employee who had recognized its awesomeness. I think, in that moment, the idea of finding and collecting altered covers was born for me. From there, they began to appear. I shop for a living, as a partner in the vintage design store, The Window, so I'm out looking a lot. Sunday mornings have been a faithful flea market ritual for a long, long time. Additionally, since getting back into collecting vinyl (primarily rare Jazz and avant garde records), I spend a lot of my free time making the rounds in the L.A. record shop scene. I like the dual mission of looking for the cleanest, best examples of rare spiritual Jazz LPs while simultaneaously scouring the dollar bins, hoping to find a Carpenters' record where some kid I'll never know decided to black-out some of their teeth! I often wonder, but will never know, how each of these defaced covers, found in the wild, came to be.

Once I jumped into the defaced hole, I realized that the range of defacing was wide—so many subcategories, from really thought-out

and artful to just blatently disrespectful. Bloodshot eyes, blackened teeth, moustaches, tattoos, reviews, love letters, collage, psychedelia, pornography, etc. Sometimes over-the-top and other times wonderfully subtle—and often, really funny too! I can't help but see these as anonymous and personal folk art of some sort.

After years searching, almost daily, something unexpected happened. The excitement of the collection spread throughout the vinyl community. A core crew of good friends had already been contributing to the cause, passing along their own finds. But now, the word had spread enough that even strangers joined in. People I'd never met would stop me and say, "Aren't you the defaced guy? I have one for you." I can't help but feel the community in this—a sharpened compulsion and a shared vision. A collection that won't stop growing. Marred for life!

ACKNOWLEDGEMENTS

I would like to express extra power thanks to Jason from J&L Books for really "getting it" and being the dream collaborator. Your creative vision, ability to see the most sublime humor, and from it, create a wonderfully fun and interesting narrative, blew me away. It was really exciting, watching this book evolve and take its final form. Your extraterrestrial editing skills made this digger/gatherer/collector's mass of material into something worth sharing with the world. Thank you!

Huge thanks to Trevor for inspiring this grasshopper to walk fearlessly on all of the world's rice paper—you've shared SO much with me and encouraged me to never stop listening, learning and searching. I'm deeply grateful for your encouragement - without you, there would be no Uncle Power. Your friendship & influence on my musical journey is immeasurable. JFF!

Shoutout to the whole Atomic Records gang (Steve, Rick, Sam, Drew, Alan & Bella) for providing the ultimate clubhouse and home away from home; not to mention the seemingly, never-ending supply of incredible records! "There will be more" is the mantra for not only the amazing records still to come, but also for the late-night hangs, stories of record

lore and the always interesting cast of characters in our collective Atomic future. "It's in a box."

Giant props to Lance for his extraordinary contribution to the defaced cause—you are a supreme digging force and the hardest working dude in the biz. Your willingness to always have me (and Tarkus!) in mind, is deeply appreciated. Right On.

A power thank you is essential and in order to "Choice" for his remarkable, defaced digging determination. No one crushes the dollar bins harder nor has a greater enthusiasm for the soul of this project. Mike is perhaps the greatest example of the positive energy, joy and excitement that I've felt from the collective consciousness of "Marred For Life". Thanks, brother.

Thank you, BMC, for giving me the bug again (my instant karma for moving your record collection up all those steps!)—and for the fun, musical education we continue to experience together, as we listen-to and share our love of music while at "work". That "Rip, Rig and Panic" moment really launched something in me—thank you.

Thank you deeply, Jimbo & Audbo, for a lifetime of support and encouragement. You raised me in a dome of music & love and allowed me to grow and pursue life, outside the dreaded box of normalcy. From Hot Wheels to Hot Rats ("album of the century!"), it's always been a special, love-filled and fascinating journey. I can't possibly overstate how blessed I am to have the parents I have —I love you both, dearly.

Maximum possible love to my dearest Dee, for encouraging my collecting passion & for helping me get my compulsion to a positive place—and for never complaining about the disappearing floorspace! The support and positivity you show your vinyl-obsessed man are truly exceptional. Thank you for being so cool about all this crazy collecting—I am a very lucky man to have such a loving, understanding and supportive woman in my life. A love supreme.

I'm deeply grateful to all who contributed to the defaced cause —the collective enthusiasm for this project really added an exciting and special energy to "Marred For Life" that I never expected or imagined. My ever-expanding community of vinyl freaks really showed up to raise the barn roof! Thank you, all!!

The following is an alphabetical list of those who in one way or another, have helped to make this happen:

Academy Records NYC, Steve Aldana, Rick Alper, Steve Alper, Amoeba Music, Atomic Records, Augie, Avalon Vintage, Trevor Baade, Bernadette's, Kyle Bitters, Adam Blackman, Bldngblck, Blue Arrow Records, Blue Bag Records, Bunny, Zac Burgenbauch, Butter, Amador Calvo, Scott Carlson, Paco Casanova, Brad Caulkins, CD Trader, Lorca Cohen, Erin Covert, Cooper, Dean Crane, The Damamas, Kamau Daáood, Jeffrey David — The Lost RPM, Sean Dobbe, DJ Captain Choice, Kyle Donaldson, Doug Erb, Ken Erwin, "Desert Bob" Fisher, Folk Arts Rare Records, Freakbeat Records, Gimme Gimme Records, Glass House Record Store, Going Underground Records LA, John Gomes, Ana Goncalves, Greater Orange County Record Show, Matthew Green, guzzofunk, David Hale, Heath/ Cosmic Vinyl, Tim Hellwig, Michael Hentz, Kris Herndon, High Fidelity, Jacknife Records & Tapes, Jockamo Records, George Jensen, Deirdre Keeley, Marty Key/Steady Sounds, Eric Kvatek, Innis Lawrence, Leon's Curation, Lost RPM, Masa of Echo Park, John Miner, Mono Records, Ronnie Morales, Rick "5000" Morris, Clark Nelson, Carlos Niño, Chris Osmundson, Troy Parker, Robert Page, PCC, Permanent Records, Sam Phipps, Prettiest Eyes, Rappcats, Record Jungle, Record Parlour, Record Surplus, Recurring Records NYC, Rick & Carlos, Rockaway Records, Salvage Sound, Tony Santos, Luke Scarola, Drew Scharlatt, Miles Cooper Seaton, Patrick Shiroishi, Sean Smith, Matt Stikker, Jeremy Szuder, Table 5 Records, Henry Tenney, Mike Vague, Mark Velo, Hector Waluyo, Marc Weinstein, James & Audrey Wooten, Zebulon, Lotar Ziesing, Andrew Zuckerman, @texashydrangea

— Greg Wooten

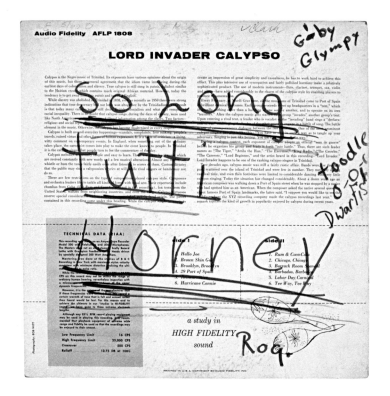

Marred for Life!
Defaced Record Covers from the Collection of Greg Wooten

Book design, edit and sequence by Jason Fulford

Phive is a typeface by Nick Sherman at Hex Projects, inspired by
Stephenson & Blake's Condensed Sans Serifs No. 5.

ISBN 978-0-9993655-2-6
Printed in South Korea

www.JandLbooks.org